POSTCARD HISTORY SERIES

Hudson River

from New York City to Albany

In September and October 1909, New York State threw many parties to celebrate the 300th anniversary of the European discovery of the Hudson River. They also celebrated the 100th anniversary of the invention of the steamboat, which would change man's relationship to the river. Sail with us on either Hudson's *Half Moon* or Fulton's *Clermont* as we travel from New York to Albany and a bit beyond.

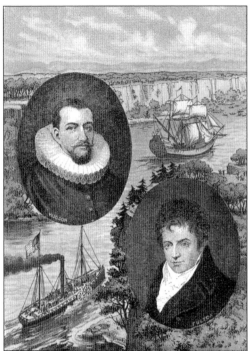

COPYRIGHT 1909 BY J. KOEHLER, N.Y.

1609 · HUDSON - FULTON CELEBRATION · 1909 ·

Sept. 25	Commencement Day N. Y.	Oct. 3	Religious Day Upper Hudson
,, 26	Religious Observance Day N. Y.	,, 4	Dutchess Co. Day
,, 27	Reception Day N. Y.	,, 5	Ulster Co. Day
,, 28	Historical Parade N. Y.	,, 6	Greene Co. Day
,, 29	Commemoration Day N. Y.	,, 7	Columbia Co. Day
,, 30	Military Parade Day N. Y.	,, 8	Albany Co. Day
Oct. 1	Naval Parade N. Y.	,, 9	Rensselaer Co. Day
,, 2	Naval Carnival Parade N. Y.		

Statue of Liberty, New York City.

The Hudson flows into New York Bay, which has been dominated since 1886 by the Statue of Liberty, whose torch is held 306 feet above the water. An early airplane is shown in this 1920s card as a testimony to America's progress. From the Dutch period on forward, the Hudson has been a gateway for millions emigrating from the Old World.

2

POSTCARD HISTORY SERIES

Hudson River

from New York City to Albany

Irwin Richman

ARCADIA

Published by Arcadia Publishing,
an imprint of Tempus Publishing, Inc.
2A Cumberland Street
Charleston, SC 29401

Printed in Great Britain.

Library of Congress Catalog Card Number: 2001091405

For all general information contact Arcadia Publishing at:
Telephone 843-853-2070
Fax 843-853-0044
E-Mail sales@arcadiapublishing.com

For customer service and orders:
Toll-Free 1-888-313-2665

Visit us on the internet at http://www.arcadiapublishing.com

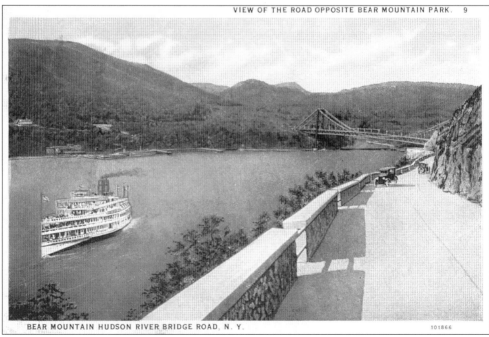

By the mid-1920s, Bear Mountain was a popular automobile destination, made possible by a road cutting through solid rock and the construction of a wondrous suspension bridge. The bridge was officially called the Peekskill-Bear Mountain Bridge. An excursion boat steams back to New York City on the broad river below.

CONTENTS

ACKNOWLEDGMENTS

The Hudson River has always been part of my life. Growing up in Brooklyn, my family and I always summered in the Catskills. I vividly remember being driven in my father's car along the West Side Drive. If we were lucky, we might see the great ocean liners the *Queen Mary* or the *Queen Elizabeth* waiting to pick up passengers. Looking across the river, we glimpsed a huge advertising sign for Palisades Amusement Park. On the land side were skyscrapers and the homes of the rich. "Chateau Schwab," the home of the president of Bethlehem Steel, loomed above Riverside Drive. Then, the George Washington Bridge came into sight. It was, and is, beautiful. As we crossed the Hudson into New Jersey, on our right was Bill Miller's Riviera, a nightclub that spelled glamour to me.

After World War II, when traveling along the west side of the river on 9 West, we passed the mothballed fleet: hundreds of no-longer-needed ships—a very impressive, if ghostly, gray flotilla.

As an adult, I have always enjoyed sightseeing along the Hudson, and professionally my interest in the artists of the Hudson River school brought me to the valley time and again. When our son Joshua chose to go to the Bard College in Annandale-on-Hudson, we had more reasons to visit. Today, to cross the Tappan Zee Bridge or the more modest Kingston-Rhinecliff Bridge is still exciting, especially when sailboats are on the river. It is truly a lordly river.

Being the president of the Parents Leadership Council of Bard College has kept me returning to the Hudson. I want to thank my Bard friends and acquaintances for keeping me involved and coming back, especially Debra Pemstein, Carolyn Mayo-Winham, and Dr. Gary Hagberg.

In writing any book, you have collaborators. I would like to thank the reference and interlibrary loan librarians at Penn State at Harrisburg who make my research possible. My colleagues, and especially the Humanities School director, Dr. William Mahar, have always been supportive, as has our associate dean for graduate studies and research, Dr. Howard Sachs.

My mother, Bertha Richman, was always there in the cars of childhood that drove me along the Hudson. My wife, M. Susan Richman, shares my love of scenic beauty. Our sons inherited some of our aesthetic. Dr. Alexander Richman, a mathematician like his mother, loves the paintings of the Hudson River school. Joshua, a medical student, lives in Alabama with his wife, Kristin, and our grandchild, Benjamin David—the apple of our eye. Young Benjamin, however, clearly needs exposure to the Hudson River and its valley.

INTRODUCTION

"I'll always remember our boyhood on the River," Pres. Franklin Delano Roosevelt wrote to a childhood friend who lived several miles north of Springwood, the estate near Hyde Park where the future president grew up. Children of the elite as well as the less privileged often had watercraft, which enabled them to develop friendships along the Hudson's banks. Franklin's distant cousin Theodore Roosevelt, our 26th president, was born in New York City in 1858. Go back in time almost a century from Franklin Roosevelt's presidency (1933–1945) and you meet a third president born in the Hudson Valley. Martin Van Buren (1782–1862), the son of a tavern keeper, grew up in the town of Kinderhook, which would remain his home. Prospering, he emulated his more aristocratic neighbors and developed an estate, Lindenwald, where he would live in retirement. Franklin Roosevelt, our 32nd president, was one of our most successful. Martin Van Buren, our eighth, was a single-term president who had the misfortune of following the popular hero Andrew Jackson. While Van Buren's presidency is largely forgotten, his campaign slogan has become part of American speech. Called by his supporters "Old Kinderhook," they urged citizens to vote "O.K." Both Franklin Roosevelt and Van Buren were Democrats. Theodore Roosevelt was a Republican. All three were Holland Dutch in ancestry.

The story of European settlements along the Hudson is diverse, beginning with the exploration of what English mapmakers had called the "North River." In 1609, Dutch explorer Hendrick (Henry) Hudson sailed the ship *Halve Maen* (Half Moon) down the river. The Hudson River did not lead, as hoped, to the elusive, nonexistent, but legendary Northwest Passage for which he searched, and Hudson lost his life on a later voyage of discovery. Based on his efforts, the government of Holland claimed the Hudson Valley. Claims to the "South River" (the Delaware) were also based on his and the work of other explorers. A mercantile company, the Dutch West India Company was established to develop the colony. In 1626, the Dutch explorer of French Huguenot ancestry, Peter Minuit (1580–1633), bought Manhattan Island from the Native Americans for the legendary $24 in trinkets and trade goods. History has later suggested that the Native Americans got the better deal as Minuit negotiated with visitors rather than the resident tribes.

Soon a town, Nieuw Amsterdam, was founded at the southern tip of Manhattan Island, as intimately related to the water as its Dutch namesake. A Dutch town with tile-roofed houses and windmills, it was protected by a fort at the battery to defend against the English and a wall (now known as Wall Street) to protect it from those Native Americans who never recognized Minuit's land deal. To induce settlers into their colony, the Dutch West India Company introduced a feudal system of large landholdings along the banks of the Hudson, called patroonships. Any patroon who agreed to provide settlers and build houses and a mill could be granted up to 16 miles of riverfront property and "as much inward land as needed."

Remnants of the patroon system still shape areas along the Hudson from present Westchester County to north of Fort Orange, present-day Albany. Since few Hollanders cared to immigrate, the population of Nieuw Amsterdam and the New Netherlands was polyglot almost from its beginnings: French Protestants (Huguenots), Germans from the Palatinate, Jews, and black slaves were a large part of the population. Many Dutch family fortunes, including those of the Roosevelts, were based, in part, on profits made in the slave trade. Some enterprises, such as the Philipse family's Northern Mills, were run almost entirely by slaves.

Poorly funded, pressed by the English to the north and the Swedish settlers on the South River, the days of Dutch colonial rule were numbered. The last Dutch governor of New York, Peg Leg Pieter Stuyvesant (1592–1672), was arrogant and largely ineffective. Going to war against the Swedes in 1653, the Dutch won a Pyrrhic victory. They won, but they were weakened. In 1664, the English fleet, under the command of the Duke of York, sailed into Nieuw Amsterdam Harbor and no one came forward to defend the colony. Stuyvesant himself climbed the tower of the fort to fire a single cannon shot to show token resistance.

Because the Dutch had surrendered so readily, the English treated them kindly. As long as the New Netherland residents took an oath of loyalty to the English king, their landholding rights were respected. They were free to retain their own language and to enjoy the rights of Englishmen. Even Gov. Pieter Stuyvesant chose to stay in the renamed colony of New York, where he retired to his farm, Bowerie, which would later give its name to a colorful New York street, the Bowery. Stuyvesant descendants would long live in New York. The Philipse family, whose wealth was based on farming and shipping, changed their name to Philips and became such loyal subjects of the British Crown that they fought for Britain during the American Revolution and lost everything.

Dutch influences remain even today. *Olie-koecken,* or donuts, are a Dutch contribution to our culture, as are place names such as Staten Island, the Bronx, Brooklyn, Flatbush, Harlem, Kinderhook, Bushkill, Greenbush, Fishkill, and the Tappan Zee—the last being the widest part of the Hudson River. While many congregations joined the United Church of Christ in the 20th century, other congregations of the Dutch Reformed Church still proudly retain their original name and their independence. The Holland Society, a patriotic group whose members descend from pre-1664 residents of Nieuw Amsterdam, can look down upon Daughters of the American Revolution as later immigrants. Architect J. Edwin Green (1896–1985), who grew up in Ulster County in the Hudson River Valley, remembers people speaking Dutch during his childhood.

Often characterized as the "American Rhine," the Hudson is a vast tidal river that moves in two directions. The book *Hudson River Villas* notes, "Twice daily 150 miles of the Hudson pulses with tides, first north from the Atlantic, then south as it drains from the merger with the Mohawk River. The scenery of the Catskills, Highlands, and Palisades change as quickly as the tides. In morning the river can be pale and mirrorlike, overhung by veils of mist. Midday rays of bright sun make the river's surface sparkle like scattered diamonds. The two o'clock afternoon trade winds add texture. Then by sundown, a storm rising over the valley transforms the sky, the landscape, and the river."

Rising from Tear of the Clouds Lake, the Hudson served as a major waterway into the heart of British America. Many important battles of the French and Indian War were fought there. Some have been immortalized in the fiction of James Fenimore Cooper. During the American Revolution, the colonists, in order to prevent British ships from sailing upriver, put a chain across the Hudson at West Point. Because of its symbolic military status, the fort at West Point became the site of the United States Military Academy, founded in 1802. The Battle of Saratoga, which took place in 1778, was fought in part because of the Hudson's importance to both sides.

One of the great English landholding families who emerged following the Dutch patroon period was the Livingstons. With the coming of the American Revolution, Robert Livingston (1746–1813), the lord of the manor, tried to draft his tenants to fight for the American side. They resisted, displeased by their rents and taxes. But the pro-American Livingstons eventually triumphed. When Tory lands were confiscated by the new state legislature meeting in Kingston, the Livingstons acquired many of the vast landholdings of Frederick Philips. There are still Livingston estates in the Hudson Valley today. Some are museums, such as Clermont and Montgomery Place; others are private homes.

From the 17th century, the banks of the Hudson were dotted with great houses of the patroons and their successors. By the 19th century, many country homes and gardens lined the east and, to a lesser extent, the west banks of the Hudson River. The houses reflected all of the architectural styles of the era. Greek temples, gothic castles, and Italianate villas grew along the river—all the castles of the "American Rhine." Not domestic, but most fortresslike of all in its formidable purpose is the penitentiary at Sing Sing.

The opening of the Erie Canal in 1825 and the Delaware and Hudson Canal in 1828 enhanced the river's importance as a major avenue of commerce—a role it would play until the triumph of the railroad and highway ages. However, freight still moves on the Hudson.

The river is easily navigable until north of Albany, where the name of Kiliaen Van Rensselaer still resonates today. Van Rensselaer was an Amsterdam diamond merchant, a director of the Dutch West India Company, and a patroon. His upriver holdings incorporated all of present Albany and Rensselaer Counties. The most successful of the patroon families, the Van Rensselaers functioned as the feudal lords of their tenants until the anti-rent riots of the 19th century, which ended their power.

The river was traveled by sailboats and sloops of all kinds. In 1809, a great change came when the *Clermont*, Robert Fulton's steamboat, financed by the Livingston family, proved itself on the river. The steamboat shortened the travel time from New York to Albany. The new vessel made it possible for wealthy New York City residents to have summer and even weekend homes along the Hudson's banks. Steamboats on the Hudson can be considered America's first hot rods, as captains raced one another for bragging rights as to who had the fastest ship. In 1852, Andrew Jackson Downing, a landscapist and architect who popularized the region's beauty, died while riding the steamboat *Henry Clay*. The boat exploded due to an overheated boiler.

The railroad made travel along the Hudson even faster and eventually replaced the steamboat as the primary means of transportation. Excursion boats, developed in the 19th century, continued well into the 20th century, until the automobile age essentially made them obsolete. On day trips, New Yorkers could travel to Bear Mountain, West Point, or perhaps Kingston and back. Hudson River Dayliners were part of the author's childhood. A few boats still survive to serve a more limited market today. Small excursion boats also operate out of Albany and Kingston in warm weather. Pleasure boating is ever more important on the river, and many towns along the river feature marinas. Sailboats remain a river staple. Fishing remains popular on the Hudson, but the vast commercial fishing of earlier years has vanished.

In many ways, the river has been the cynosure of American literature and art in the 19th century. James Fenimore Cooper, in the 1832 novel, *The Heidenmauer*, became the first major author to compare the Hudson to the Rhine, but it is Washington Irving, perhaps his era's most popular author, who was left us the richest Hudson River literary heritage. Born in New York City, Irving grew up along the river. "I thank God," he wrote, "that I was born on the banks of the Hudson. I fancy that I can trace much of what is good and pleasant in my heterogeneous compound to my early companionship with this glorious river . . . I used to clothe it with moral attributes, and, as it were, give it a soul. I delighted in its frank, bold, honest character; its noble sincerity and perfect truth. Here was no specious, smiling surface covering the shifting sandbar and perfidious rock, but a stream deep as it was broad, and bearing with honorable faith the bank that trusted to its waves."

Irving, with the help of an artist friend, converted an old Dutch farmhouse into Sunnyside, a fantasy on the banks of the Tappan Zee, near Tarrytown. This is only fitting for the man who gave us the hapless Ichabod Crane, the Headless Horseman, and Rip Van Winkle. As much as Irving enjoyed river travel, he welcomed the railroad when it was built mere feet from his house. He enjoyed being able to go to the theater in New York City—and to return to his own bed afterwards. While the train service, in recent years, has been reviving in the valley, it has never matched the frequency of the service before the automobile. Edith Wharton's novel *Hudson River Bracketed* talks about several changes along the river, caused in part by the automobile.

Landscape painters of the Hudson River school were the first non-portrait artists with a coherent American vision. They gloried in the river and the symbolic value of nature as the word of God revealed. Thomas Cole (1801–1848) was an English-born painter who was advised to leave New York City because of his "delicate lungs." Settling in the town of Catskill, Cole's work attracted many disciples by

the time of his early death in 1848. Cole's house was a shrine for the many artists who painted there. Most prominent of these was Cole's greatest student, Frederick Edwin Church (1826–1900). Other painters were Sanford Gifford (1823–1880), who was the only major Hudson River school artist to have grown up in the region; Charles Herbert Moore (1840–1930); and Francis Jasper Cropsey (1823–1900). To memorialize Cole, his friend, Asher B. Durand (1796–1886) painted *Kindred Spirits*, which shows Thomas Cole standing on a favored ledge near the river, discussing the sublimity of nature with poet-philosopher William Cullen Bryant (1794–1878). Today, Cole's house is a museum, as is Church's Moorish fantasy, named Olana, and Cropsey's retirement home, Ever Rest. Both of these latter houses retain their glorious views of the river.

By the mid-19th century, New York City had become a major American art center, where many of the Hudson River school painters wintered. In the post-World War II years, with the emergence of the Abstract Expressionists of the New York school, New York City became an acknowledged world-class center for art. Culturally, New York City, located at the mouth of the Hudson, is a metropolis of superlatives with its active art, theater, dance, and music worlds. Its museums are rich and varied. Among the world's greatest cities, it is the center of American publishing and finance. Modernist artist Georgia O'Keefe (1887–1986), who lived and worked in New York for many years, observed, "New York looks like a city should . . . It's tall, it puts the cities of Europe to shame." Whether one shares O'Keefe's tastes or not, one must recognize the city's continued vibrancy and its polyglot of cultures.

New York City is, of course, the most expensive place you can live in the Hudson River Valley. An advertisement in an April 2001 edition of the *New York Times* offers a 15-room apartment "at 90 Riverside Drive . . . This lavish showcase takes up an entire high floor of one of the finest apartment buildings on the Upper West Side. It spreads out over 5,500 square feet, all of its rooms are over-size, and the major ones offer glorious Hudson River Views." The price? The apartment cost $10 million.

Traveling north from New York, there are numerous river towns and cities, all interspersed with suburban tracts, farms, factories, and dumps. The natural glories of the river have been compromised. While a few man-made structures of beauty like the George Washington Bridge enhance the river like jewels on a beautiful woman, too many other riverside structures are ugly. As you go north today, many of the river's cities face hard times. Some are rising out of decay. Newburgh, where Andrew Jackson Downing worked, retains many faded mansions. Poughkeepsie, hard hit when IBM restructured, has internationally known Vassar College, which adds luster to the region. Kingston, the colonial capital city, is undergoing a restoration of its historic district and is perhaps, today, the most Dutch-appearing of the valley's cities—dominated by the spires of continental-influenced churches. Hudson, an old railroad town, has become a small city of antique shops and boutiques.

Many of the small towns are rich with history, interest, and charm. Some, like Tivoli, grew to serve nearby estates. Tarrytown is "Sleepy Hollow" territory; Hyde Park has the Roosevelt home, the Vanderbilt Mansion, and the Culinary Institute of America; Annandale-on-Hudson has Bard College, whose new Frank Gehry-designed concert hall is becoming a mid-Hudson modernist landmark.

Our journey ends with the Capital Region, a rich historic area including Troy and Schenectady but dominated by Albany, the capital of New York. Retaining traces of its Dutch heritage, such as Fort Orange, Albany has 19th-century neighborhoods and some of America's grandest late-19th-century public buildings. Gov. Nelson Rockefeller gave the city massive modern structures as well.

The Hudson River Valley, from the Capital Region south to where the river meets the Atlantic Ocean in the Upper and Lower New York Bay, is one of the most varied and exciting areas of America—a region rich in splendor and beauty, history and grandeur, poverty and decay. On balance, the exceptional and the extraordinary win.

—Irwin Richman
The Cottage, Bainbridge, Pennsylvania

One
THE EMPIRE CITY

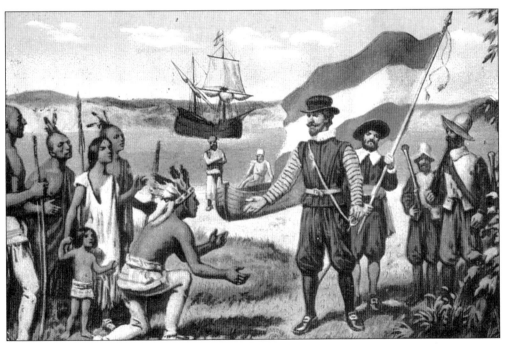

Henry Hudson took possession of Manhattan Island in the name of the Dutch East India Company, which had outfitted his expedition on the ship *Half Moon* to find an Arctic passage to India. In 1626, Pieter Minuit bought Manhattan Island from the Indians for the legendary $24 in trade goods and trinkets. This card was mailed by a tourist from Hollidaysburg, Pennsylvania, in 1909. The sender advised his friend "to slip down and take a hand in all this business"—the great Hudson-Fulton celebration.

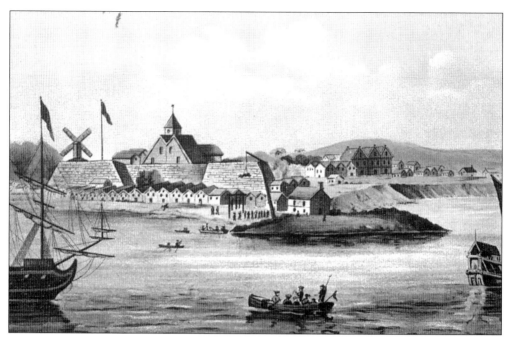

"Fort Amsterdam 'Now the Battery' in Kieft's Day" is the title of this card depicting the period when William Kieft was governor (1637–1646). Nieuw Amsterdam was a small Dutch town, with red-tile roofed houses. The town was dominated by a church, a windmill, and an intimate closeness to the water surrounding Manhattan Island.

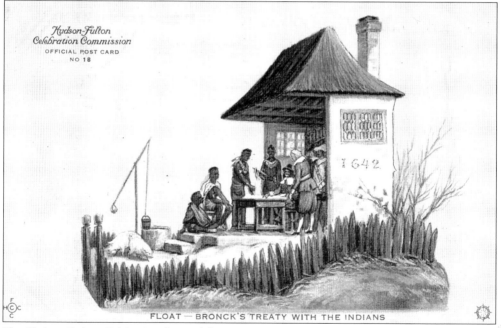

Hudson-Fulton Celebration Commission
OFFICIAL POST CARD
NO 18

1642

FLOAT — BRONCK'S TREATY WITH THE INDIANS

The Hudson-Fulton Celebration featured floats depicting many events in colonial history. Here, Jonas Bronck, for whom the Bronx and the Bronx River are named, makes a land treaty with the Native Americans in 1642. This card was mailed to a Philadelphia friend from Albany on October 7, 1909, in the midst of the celebrations.

12

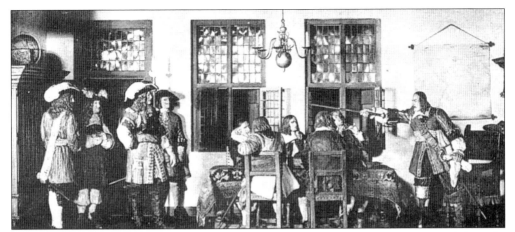

This diorama, shown in the Museum of the City of New York, depicts Pieter Stuyvesant defying the English as they demanded the surrender of Nieuw Amsterdam in 1664. When no one would support him, Stuyvesant had to surrender—and the English Royal Colony of New York was born.

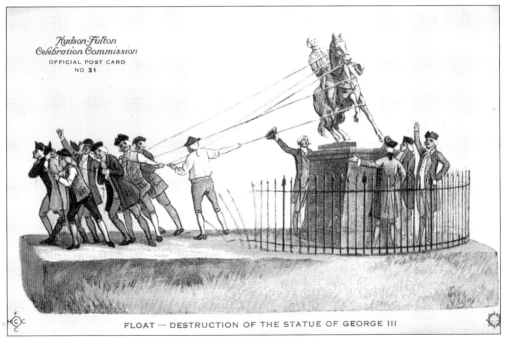

FLOAT — DESTRUCTION OF THE STATUE OF GEORGE III

On July 9, 1776, five days after the adoption of the Declaration of Independence, Patriots destroyed the lead statue of George III that stood on the Bowling Green in what is now Lower Manhattan. The road to American independence was taken, and the equestrian figure was melted down to make bullets.

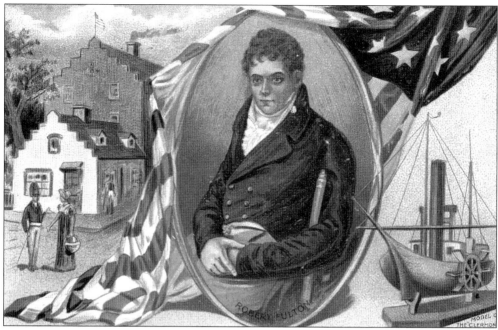

On August 11, 1809, Robert Fulton's *Clermont* set out on the 150-mile trip between New York City and Albany. At 133 feet long, 18 feet wide, and 9 feet deep, the craft, which weighed 160 tons, could travel five miles per hour. The pine wood fuel "created a continuous trail of sparks and smoke." On the upper card, a flag-draped portrait of Fulton is bordered by Dutch step-gabled buildings and a model of his ship. On the bottom card, the *Clermont* steams past the Palisades, flanked by curious folks in sailboats and rowboats.

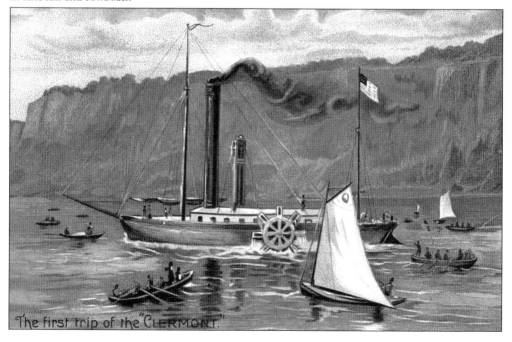

The first trip of the "CLERMONT."

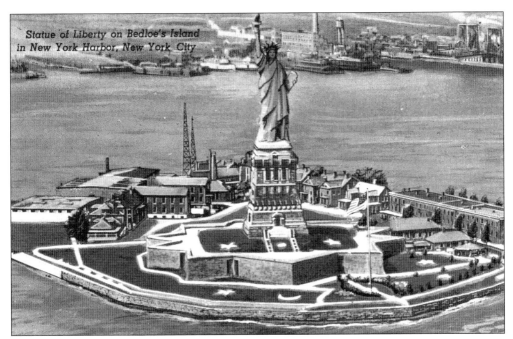

Statue of Liberty on Bedloe's Island in New York Harbor, New York City

A gift from the French government in 1884, the Statue of Liberty is the work of Frédéric-Auguste Bartholdi (1834–1904). The massive iron and steel skeleton that supports it was designed by engineer Alexandre-Gustave Eiffel (1832–1923), who later turned his genius to creating the Eiffel Tower in Paris. The statue's base was designed by Richard Morris Hunt (1828–1895), one of the first Americans to study architecture at the Ecole des Beaux Arts in Paris. The statue is erected atop a fortress on Bedloe's Island. Ending a long-lasting fight between New Jersey and New York State over who had sovereignty over the island, the Supreme Court ruled that New York holds the land under the statue. New Jersey owns the land on which the concessions (sales tax generators) stand. Behind the statue is the industrial New Jersey shoreline. The *c.* 1908 view of New York City from the statue shows a city at the brink of the great skyscraper age.

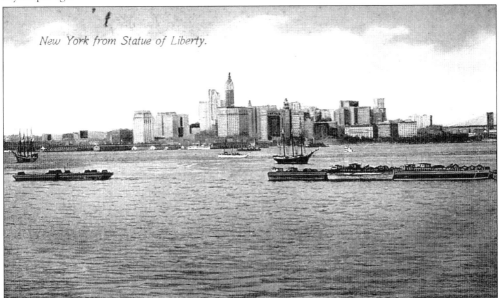

New York from Statue of Liberty.

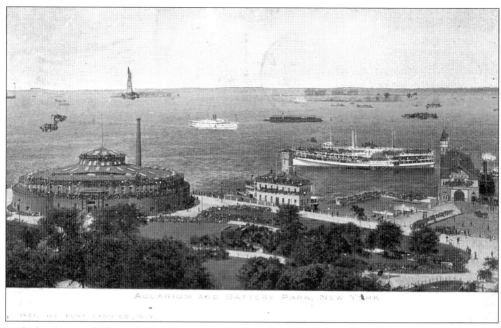

AQUARIUM AND BATTERY PARK, NEW YORK

With the Statue of Liberty in the distance, we have a view of the aquarium on Battery Park. A Staten Island, Statue of Liberty, or Ellis Island ferry boat leaves from the terminal to the right. The aquarium was originally built as Fort Clinton; later it became Castle Garden. Jenny Lind, the "Swedish Nightingale," sang here at the beginning of her triumphal tour of the United States in 1850. Before Ellis Island was developed in 1892, Castle Garden had been the major point of entry for immigrants landing in New York Harbor.

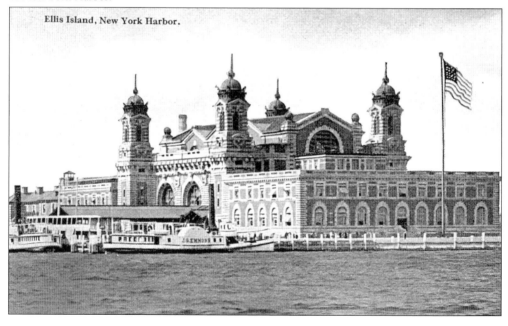

Ellis Island, New York Harbor.

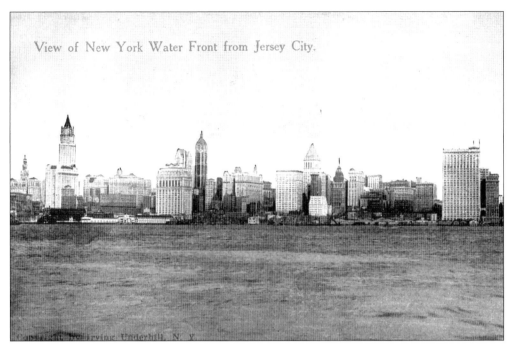

View of New York Water Front from Jersey City.

Water is as related to New York City as it is to Amsterdam. Of New York City's five boroughs, only one—the Bronx—is not located on an island. Brooklyn and Queens are on Long Island. The borough of Richmond encompasses Staten Island. Manhattan's skyline has long been a tourist destination. The view from Jersey City, above, was mailed in 1913. The card below, dating from the 1930s, shows the docks that lined the lower and midtown Manhattan waterfront. A passenger liner is visible in the middle left.

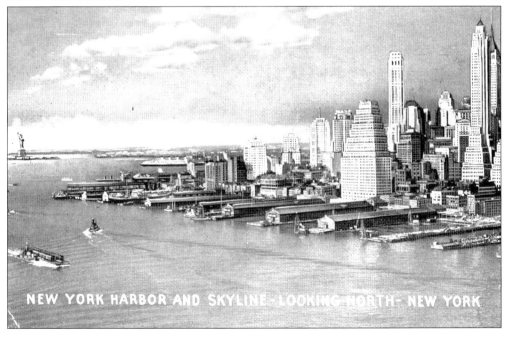

NEW YORK HARBOR AND SKYLINE-LOOKING NORTH- NEW YORK

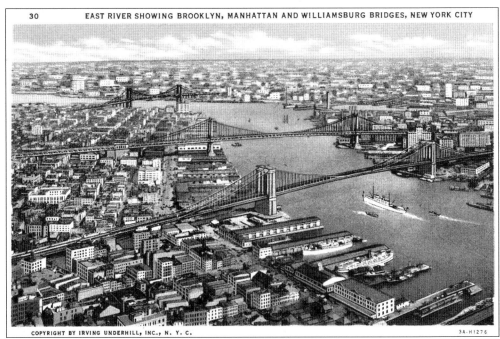

The East River is a tidal river formed when the Hudson splits around Manhattan Island. The three bridges shown link Brooklyn, which is located on Long Island, to Manhattan Island. Before the consolidation of New York City in 1898, Brooklyn was an independent city. Some residents of Brooklyn still celebrate Brooklyn Day to commemorate the day their borough joined New York City. The Brooklyn Bridge, opened in 1883, was the world's first monumental suspension bridge. The 1950s view below illustrates how narrow Manhattan Island is. The East River is in the foreground. The Hudson and a view of New Jersey are in the background. The United Nations complex is in the lower right.

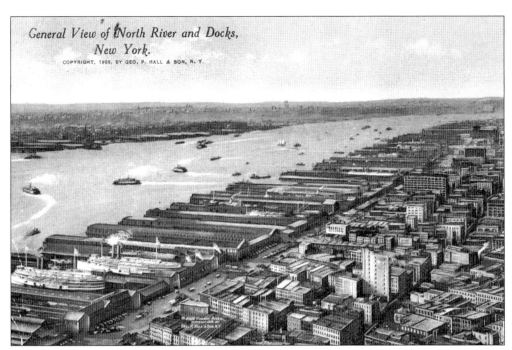

General View of North River and Docks,
New York.

COPYRIGHT, 1905, BY GEO. P. HALL & SON, N. Y.

Much of New York City's prosperity was owed to its marvelous harbor and broad navigable rivers. In these *c.* 1905 views, the Manhattan waterfront is lined with docks. Because real estate was, and is, so expensive in Manhattan, recreation piers like the one shown below, were being built late in the 19th century. Today, in the city there are still recreational piers such as Chelsea Piers, where you can play tennis and other sports while surrounded by water.

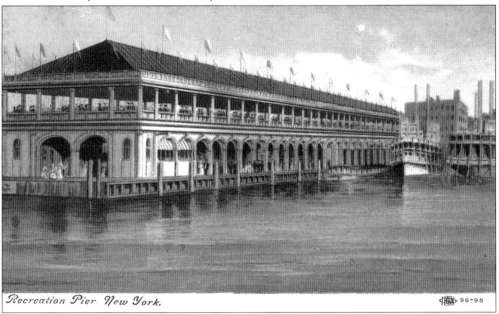

Recreation Pier New York.

96-95

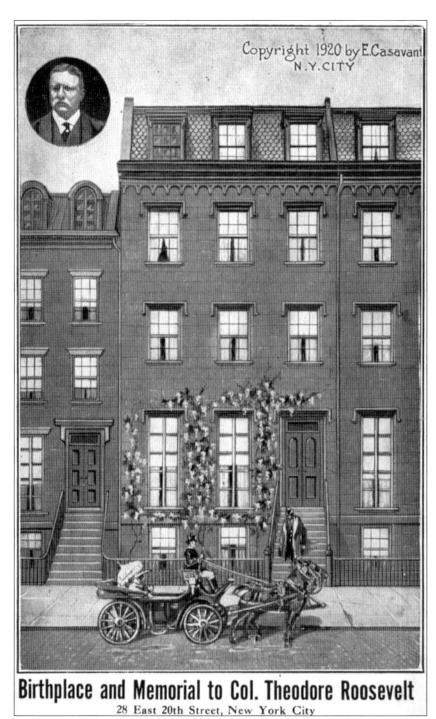

Birthplace and Memorial to Col. Theodore Roosevelt
28 East 20th Street, New York City

Pres. Theodore Roosevelt (1858-1919) was a product of old New York. Of Dutch and British Island ancestry, much of his family wealth was made in commerce. Police commissioner of New York City and governor of New York before becoming president, "T.R.," or "Teddy" was born when fashionable New York City lived below 30th Street. In always restless New York, the house was torn down. The house was rebuilt after Roosevelt's death as a memorial to him. It remains a museum.

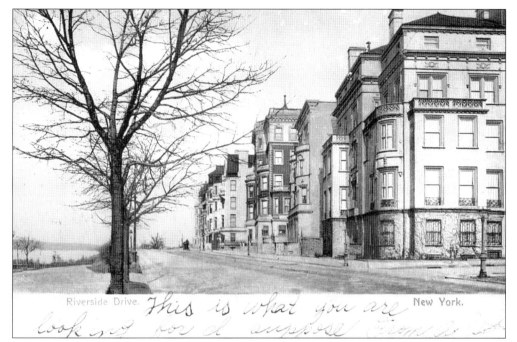

Riverside Drive. *This is what you are* New York.
look ing for I suppose From is it

Riverside Drive, high on a bluff overlooking the Hudson River, became a fashionable part of Manhattan in the last decades of the 19th century. By 1906, when the above card was mailed, the street was lined with townhouses and mansions. In the 1920s and after World War II, many of these were replaced by apartment houses. On the river below were boathouses and marinas for river craft.

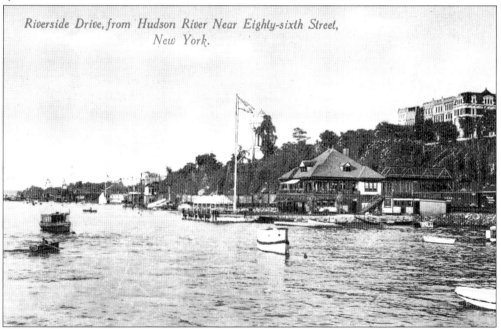

Riverside Drive, from Hudson River Near Eighty-sixth Street, New York.

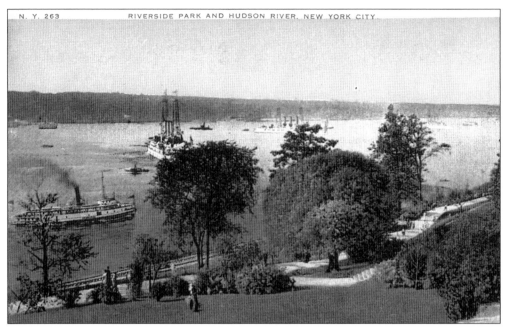

Riverside Park became one of the most stylish promenade spots in New York City, and the Riverside Drive area became the site of numerous memorials and monumental buildings. The Soldiers and Sailors Memorial was constructed to especially commemorate Civil War veterans. Busy river traffic is seen on the Hudson far below.

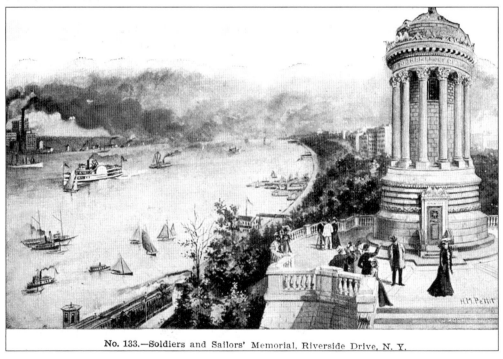

No. 133.—Soldiers and Sailors' Memorial, Riverside Drive, N. Y.

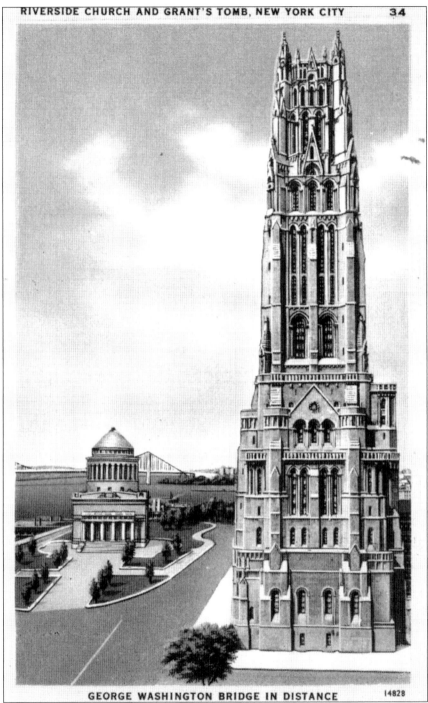

GEORGE WASHINGTON BRIDGE IN DISTANCE 14828

Riverside Church, financed by the Rockefeller family, stands on Riverside Drive near 123rd Street. Built early in the 20th century in the style of French Gothic churches of the 13th century, it remains a center of artistic and social activism. Nearby is Grant's Tomb, erected in memory of the great Union general and unfortunate United States president, Ulysses S. Grant (1822–1885). The George Washington Bridge is in the distance.

23

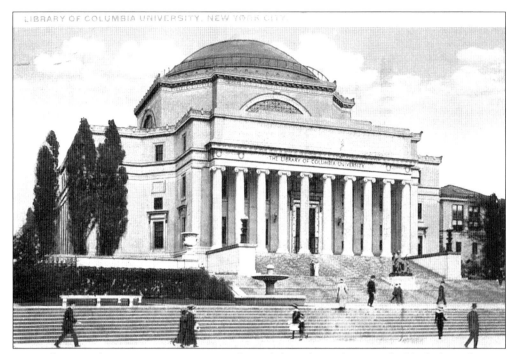

THE LIBRARY OF COLUMBIA UNIVERSITY

Many of New York City's great institutions are located along the Hudson. Perched high above the river on Morningside Heights is Columbia University. Its monumental Low Memorial Library was designed by the firm of McKim, Mead, and White early in the last century. Right at river's edge is the massive Art Deco New York Hospital, which was built in the 1920s.

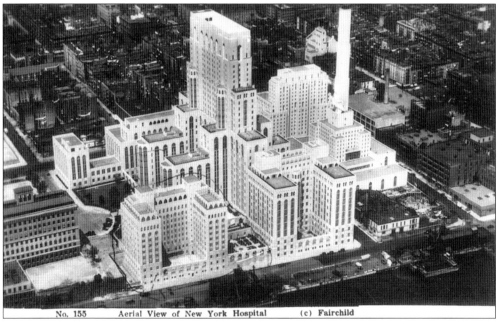

No. 155 Aerial View of New York Hospital (c) Fairchild

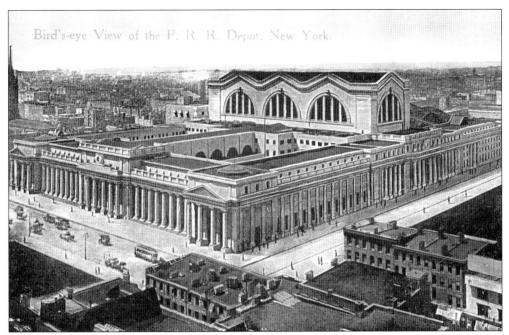

One of New York City's greatest buildings was the famed Pennsylvania Station built by McKim, Mead, and White in 1911. Its destruction in 1965 led the way to the modern historic preservation movement. Central to the success of the expansion and growth of the Pennsylvania Railroad was the tunnel 60 feet below the Hudson that allowed its trains direct access to New York City. The railroad tunnel opened in 1906.

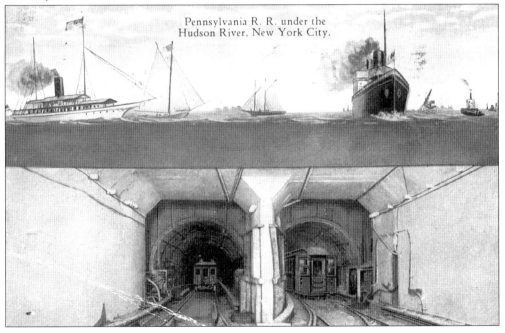

Pennsylvania R. R. under the Hudson River, New York City.

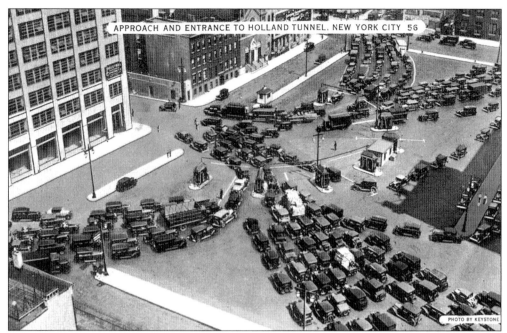

PHOTO BY KEYSTONE

The automobile age made it imperative that Manhattan Island and New Jersey be connected for easy vehicular traffic to replace the strained ferry system that shuttled cars across the Hudson. The Holland Tunnel, entering Lower Manhattan at Canal Street, opened in 1927. It was named for chief engineer Clifford M. Holland, who died during its construction. The Holland Tunnel was followed in 1945 by the Lincoln Tunnel, at midtown. One of the great engineering feats in the designs of both tunnels was to ventilate them so that exhaust fumes would not reach dangerous levels. An unimpressed midwesterner, not awed by the Holland Tunnel, wrote that driving through its tile-lined tubes "was like going through the longest public bathroom in the world."

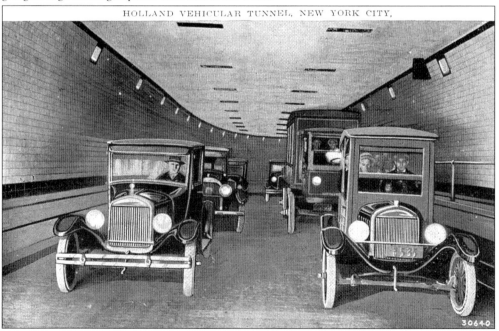

HOLLAND VEHICULAR TUNNEL, NEW YORK CITY,

30640

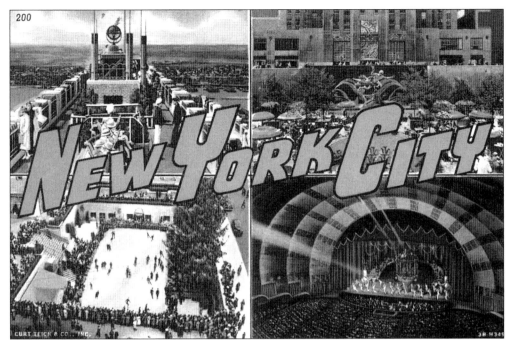

Rockefeller Center, developed during the Depression, is a great urban complex and a pioneer multifunction real-estate development. The ice rink is a must for all tourists to visit. The lighting of the Christmas tree is now broadcast nationally. Radio City Music Hall and the Rockettes are also American institutions. Rockefeller Center's signature building is the RCA (now the GE) Building, designed by modernist architect Raymond Hood. The building's Rainbow Room is an Art Deco masterpiece. The view of the Hudson River, with New Jersey in the background, from its promenade roof garden was unimpeded and glorious.

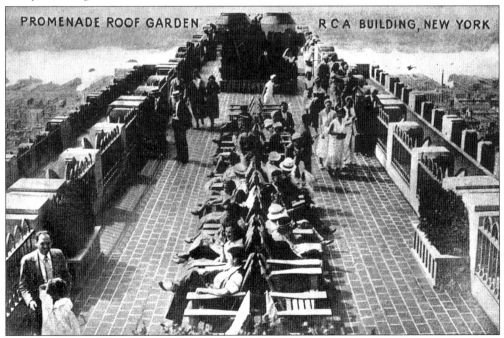

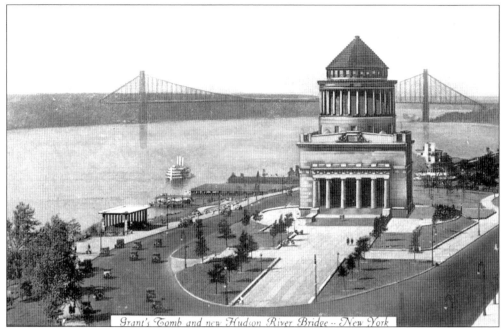

Grant's Tomb and new Hudson River Bridge -- New York

The George Washington Bridge, designed by Othmar Amman and opened in 1931, is a fitting backdrop for monumental Grant's Tomb. Originally, the exposed structure of the bridge's towers was to be sheathed in stone, but the Depression forced economy on the builders. The lower card, which emphasizes the bridge's grace, was mailed during World War II to a young lady in Springfield, Massachusetts. Passed by a military censor, the message says, "a few lines to let you know that I'm somewhere in New York now but can not tell you just where . . . I'm in the best of health."

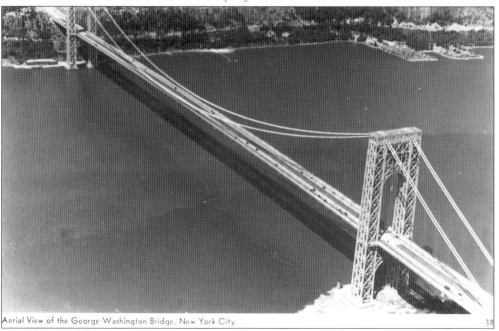

Aerial View of the George Washington Bridge, New York City. 38

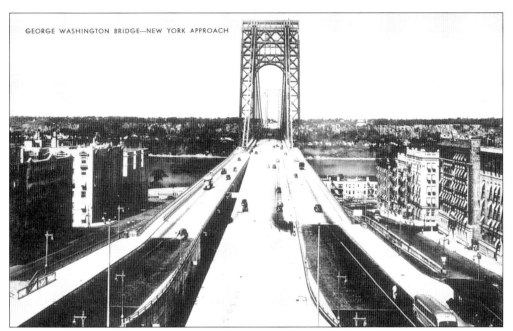

GEORGE WASHINGTON BRIDGE—NEW YORK APPROACH

The approach to the George Washington Bridge was impressive. As a small boy, the author remembers his father letting him hand the toll taker the 25¢ toll. Ancient history, archaic price! The bridge across the Hudson was, for many, the quickest way to get to the Catskills in the days before the Thomas E. Dewey (New York State) Thruway was constructed.

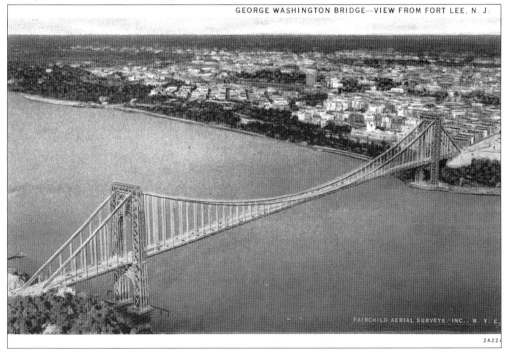

GEORGE WASHINGTON BRIDGE—VIEW FROM FORT LEE, N.J.

FAIRCHILD AERIAL SURVEYS.-INC., N.Y.C.

2A224

The legend on the back says it all: "Stupendous structure of steel stretches across the Hudson River from 178th Street Manhattan to Fort Lee, N.J. The structure is the longest suspension span in the world being 3,568 feet long and cost over $60,000,000 to construct." In 1958, a lower deck was added to the bridge.

29

Before the George Washington Bridge was constructed, Fort Lee was a quiet town. Palisades Amusement Park, shown on this card mailed in 1910, later become large and gaudy. As real estate became increasingly valuable, the park was replaced by office buildings and apartment houses. Because of its rural nature and closeness to New York City, Fort Lee was the site where many silent films and early talkies were made.

Two
THE AMERICAN RHINE

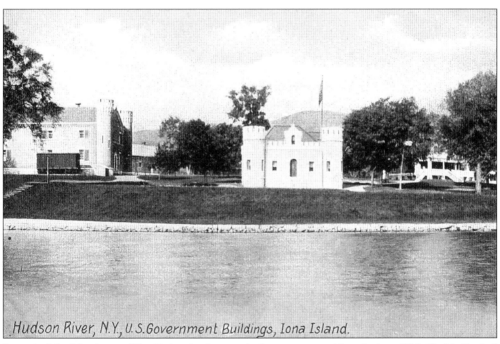

Hudson River, N.Y., U.S. Government Buildings, Iona Island.

Several of the islands near West Point also have, or had, governmental installations. This Gothic Revival building is a fitting introduction to the American Rhine. Iona Island served as a U.S. naval arsenal from 1900 until after World War II. Historian Carl Carmer claims that Rhine wine made in the Hudson Highlands is superior to that made in Germany and that one of the finest champagne grapes is the Iona, developed on this island.

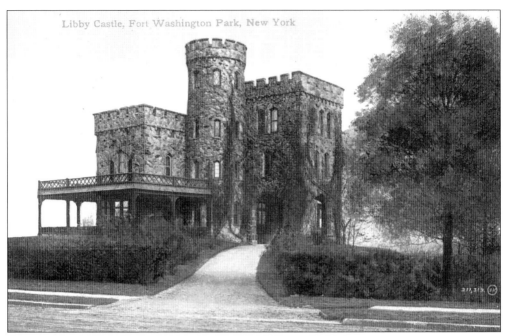

Overlooking the Hudson at Fort Washington, Woodcliff was designed by Alexander Jackson Davis (1803–1892) for importer Augustus C. Richards in 1855. The castle went through many owners, including Boss Tweed of Tammany Hall. The landmark importance of Libby Castle, as it was called *c.* 1905, did not save it. The castle was torn down and replaced with a housing project in 1939.

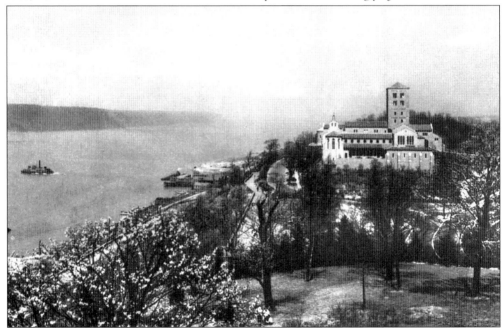

Among the most incredible of the Hudson's castles is the Cloisters in Fort Tryon Park, which houses much of the medieval collection of the Metropolitan Museum of Art. The Cloisters was begun by a Pennsylvania-born sculptor named George Grey Barnard (1863–1938), who interested John D. Rockefeller Jr. in the project. It was opened in 1939.

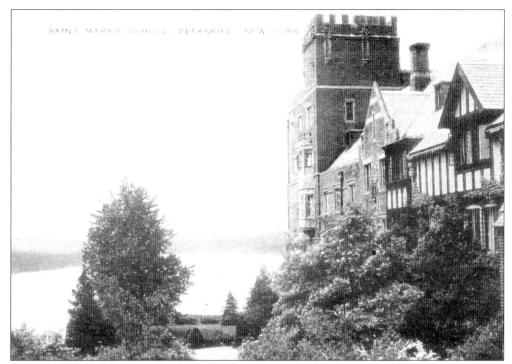

SAINT MARY'S SCHOOL, PEEKSKILL, NEW YORK

Many private castles became schools or monasteries. St. Mary's School occupies a prominent site overlooking the Hudson on top of Fort Hill. Ericstan, the Rhenish granite castle at Tarrytown, was designed by Alexander Jackson Davis for steamship magnate J.J. Herrick. It was a school from 1890 to 1933. In 1944, it was demolished as a development site.

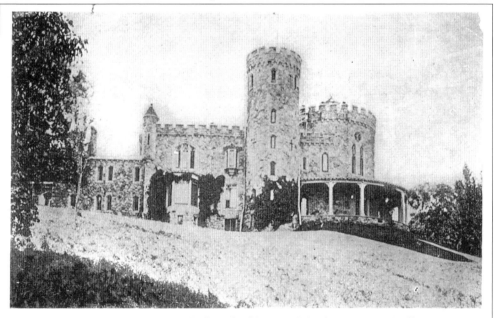

"The Castle." Tarrytown. N. Y. Miss Mason's School for Young Ladies.

33

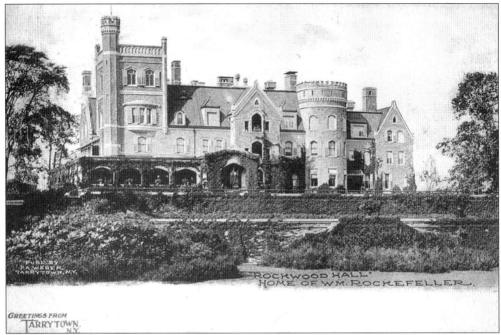

John D. Rockefeller and his lesser-known brother, William, both had estates overlooking the Hudson. Rockwood was built in 1849 and was doubled in size in the 1880s by William Rockefeller. It was demolished three years after William's death in 1922. Kykuit's story has a happier ending. The home of both John D. Rockefeller Sr. and Jr., it was designed by the firm of Aldrich and Delano in 1902 and was enlarged in 1911–1913. To preserve the magnificent view across the Hudson, the Rockefellers bought the river's west shore, which became Palisades Park. Kykuit is now open to the public. In warm weather, it can even be visited by excursion boat from New York City.

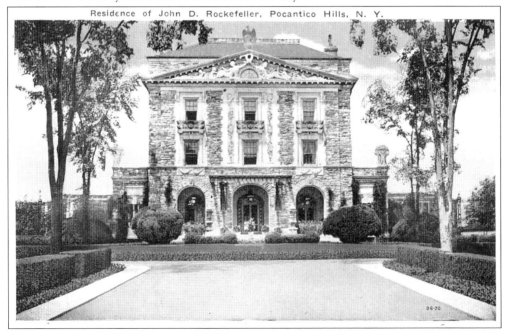

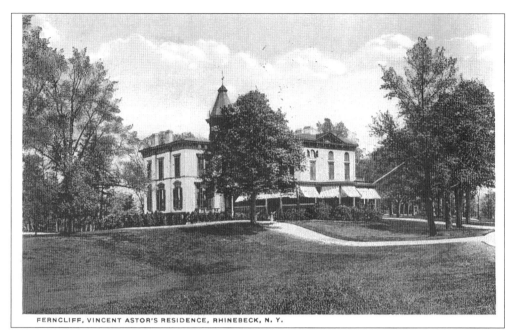

FERNCLIFF, VINCENT ASTOR'S RESIDENCE, RHINEBECK, N. Y.

Ferncliff was built on a high plateau overlooking the Hudson near Rhinebeck. It was built by William Astor, the son of William Backhouse Astor, who owned nearby Rokeby. Vincent Astor, the grandson of the estate's creator, had the house demolished after a bitter divorce from Helen Huntington Astor, with whom he had shared the estate for 25 years.

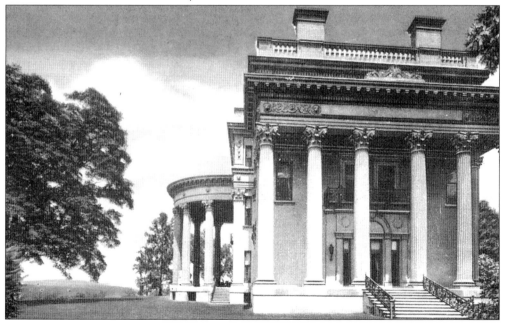

The Vanderbilt Mansion is the most recent house to be built on this site with a commanding view of the Hudson and the Catskills. The first dwelling, Red House, was built by New York physician John Bard in 1764. When the Frederick Vanderbilts bought the estate, it already had a massive 19th-century house, which they had demolished so that this Renaissance palace, designed by McKim, Mead, and White in 1895, could be constructed on this perfect site.

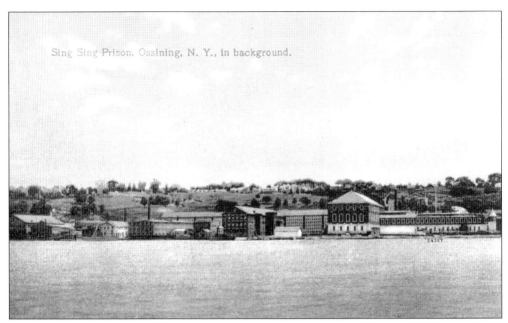

Sing Sing Prison, Ossining, N. Y., in background.

Sing Sing means prison to many people. The name comes from the Indian *Sink-Sink*, which means "stony place." The prison was founded in 1826 and was expanded over the years. Much of the site is a series of rolling hills collectively and incongruously called Mount Pleasant. The main building, shown above, is 10 feet above flood level and 480 feet long. Because the prison was always crowded, New York State bought the Bear Mountain area as the site for a new Sing Sing in 1908. Prisoners were even moved there to start clearing land. A public outcry stopped the project and the existing penitentiary has been expanded. Sing Sing, today, is not a tourist friendly environment, but Bear Mountain Park is.

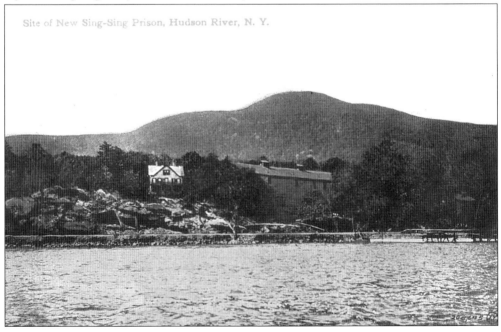

Site of New Sing-Sing Prison, Hudson River, N. Y.

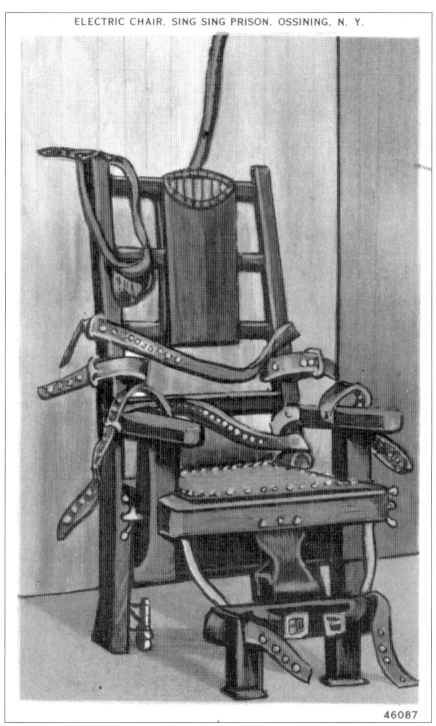

ELECTRIC CHAIR. SING SING PRISON. OSSINING. N. Y.

46087

One sight which very few, if any, Hudson River excursionists ever saw, but which has always fascinated many, was New York's "more humane modern form of execution," the "hot seat," housed at Sing Sing. The Ruben Publishing Company, in nearby Newburgh, helped satisfy tourists' curiosity with this c. 1940s card.

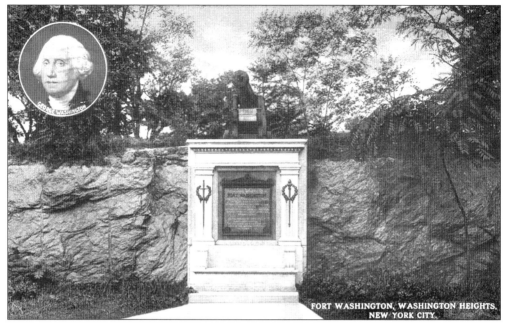

FORT WASHINGTON, WASHINGTON HEIGHTS, NEW YORK CITY.

Numerous battles and skirmishes were fought along the Hudson during the American Revolution. Most were not American victories. Fort Washington, which occupied a promontory overlooking the Hudson in both directions, was defeated by an overwhelming English and German military force in November 1776. Looking on was a dejected George Washington, who watched from Fort Lee, New Jersey, across the river. Stony Point was a psychological victory for the patriots. The fort, built in 1779 at the base of the Palisades, was captured by the British on June 1. On July 15, Mad Anthony Wayne took back the fortification. Although it was soon retaken, the revolutionaries were able to move their cannon to safety during the skirmish.

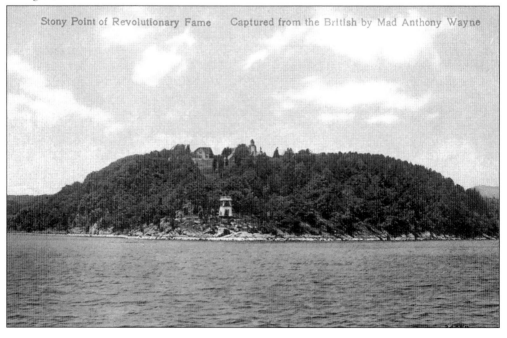

Stony Point of Revolutionary Fame Captured from the British by Mad Anthony Wayne

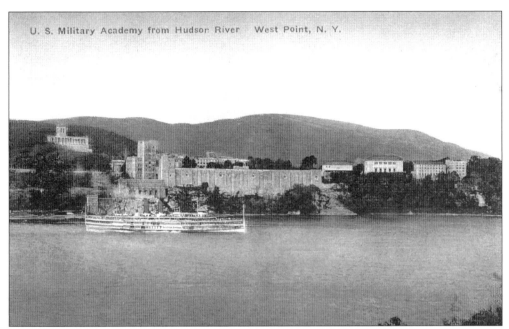

U. S. Military Academy from Hudson River West Point, N. Y.

Due to its strategic location, West Point has been called the "Gibralter of America." Because of sharp bends in the river, ships had to change course here—and they came virtually to a halt, becoming easy targets for guns on the shore. Heavily fortified during the Revolution, the various fortresses built here never fell to the British, despite Benedict Arnold's treason. In 1778, a mighty chain was stretched across the river from West Point to Constitution Island. As the excursion boat demonstrates, for many years West Point has been a popular tourist destination.

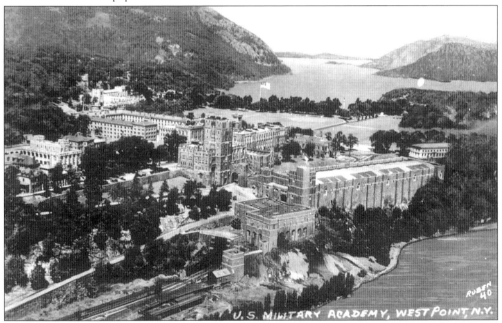

U.S. MILITARY ACADEMY, WEST POINT, N.Y.

39

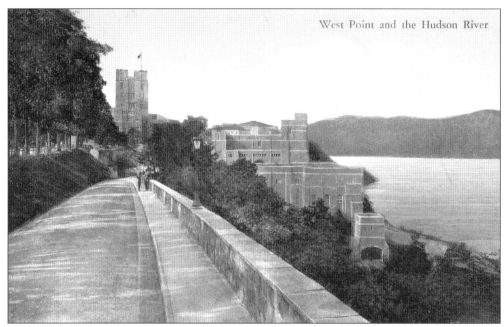

In 1786, George Washington proposed West Point as the location of a national military school. In1802, Congress formally authorized the military academy, which opened on July 4 of that year. Maj. Sylvanus Thayer (1785–1872), an early commandant, is credited with making West Point into a premier military school. Many of his principles are still followed today. Various West Point buildings loom over the river like great fortresses. Flirtation Walk wends down to the riverfront where the great chain was anchored. At one point, the path is overhung by Kissing Rock, so named because of a useful tradition—if a cadet and his true love pass underneath and he fails to kiss her, the rock will crush them both.

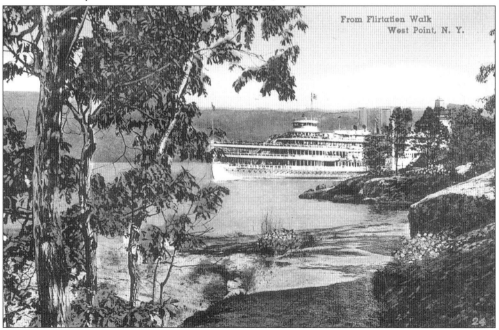

From Flirtation Walk
West Point, N. Y.

40

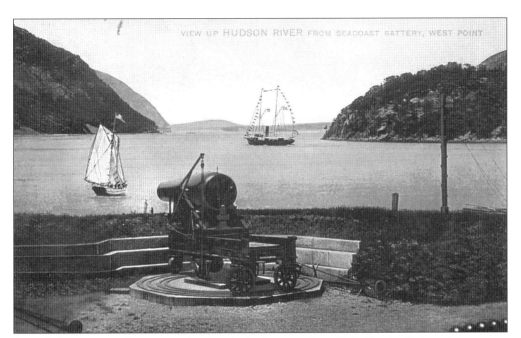

One of the most scenic spots on the river is the battery, also called Trophy Point, where a great monument was erected in memory of regular army killed during the Civil War. Constitution Island stands in the river's center. On the upper card, a gun seems ready to take out a pleasure craft. Tourists generally found the area inviting, and the hills around West Point had many hotels and boardinghouses during the 19th century. Most visitors, however, were day-trippers on excursion boats. "Doc" writes in 1909, "I went up this river 50 mile [sic] this is a fine trip." On the lower card, "Bill" writes from New York City in 1907, "Just back from West Point. Now for the Great White Way . . ."

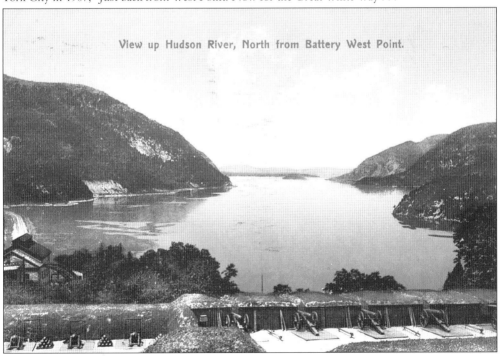

View up Hudson River, North from Battery West Point.

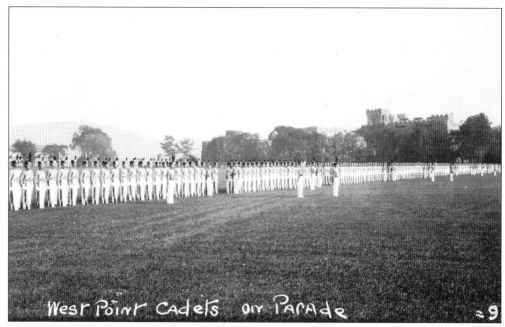

For many, the cadets are the most fascinating sight at West Point, especially when they parade. These early-20th-century cards show the corps in dress uniform on parade and in the less formal everyday uniforms after they break rank. Cadets live a strict military life in an atmosphere where learning is stressed. Among the most famous military graduates of West Point are several future presidents of the United States: Andrew Jackson, Ulysses S. Grant, and Dwight D. Eisenhower.

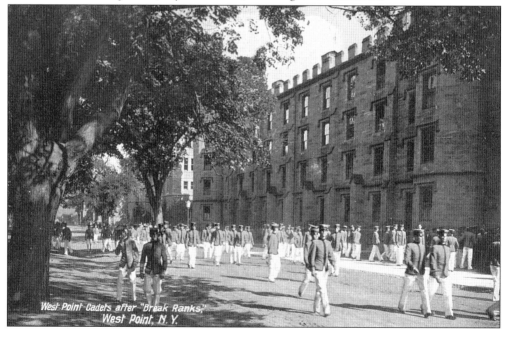

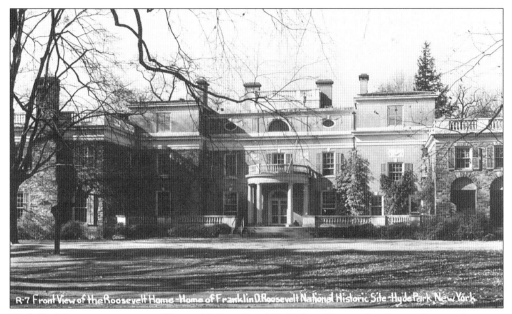

R-7 Front View of the Roosevelt Home - Home of Franklin D. Roosevelt National Historic Site - Hyde Park, New York

Hyde Park is synonymous to millions with Pres. Franklin Delano Roosevelt, who was born at the estate called Springwood in 1883. Over the years, the house went through many changes, assuming its present appearance in 1916. The sweeping lawns to the back of the house provide a splendid view of the Hudson River. Many photographs show the Roosevelts enjoying their river view. It was here, too, that Roosevelt and his wife entertained King George VI and Queen Elizabeth at a hot dog and hamburger cookout. Since 1946, the house has been a museum. On April 15, 1945, three days after his death, Roosevelt was buried in the estate's rose garden. In 1962, Mrs. Roosevelt was buried beside him.

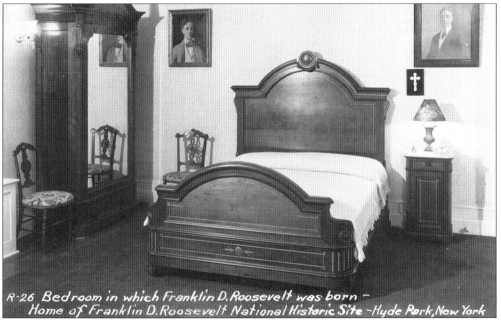

R-26 Bedroom in which Franklin D. Roosevelt was born - Home of Franklin D. Roosevelt National Historic Site - Hyde Park, New York

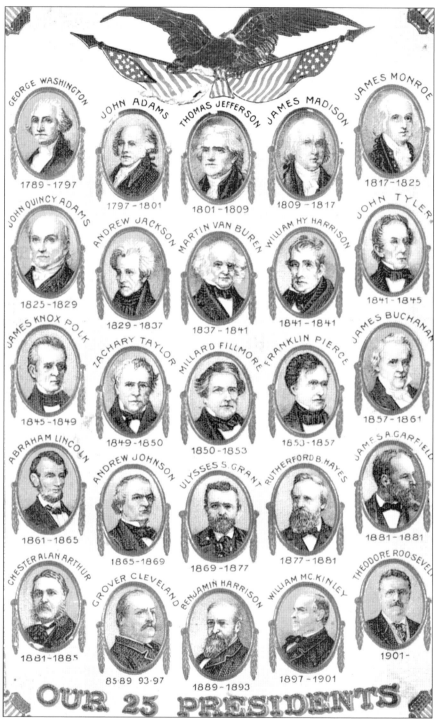

Martin Van Buren (1782–1862), the eighth president, was born and died in the town of Kinderhook, which is slightly inland and cannot be seen from the river. His home, Lindenwald, also known as the House of History, is now open as a museum. A tavern owner's son, Van Buren, emulating his more aristocratic neighbors, developed his home into an impressive estate.

44

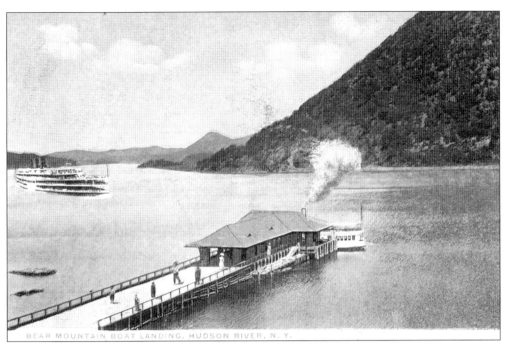

BEAR MOUNTAIN BOAT LANDING, HUDSON RIVER, N.Y.

Historically called Bread Tray Mountain or Bear Hill, Bear Mountain presumably was named for the quantity of ursine creatures in the area; however, it is likely that the name is a corruption of "Bare Mountain," referring to the mountain's rather bald summit. By 1915, as part of the Palisades Interstate Park, Bear Mountain became a major recreation destination for New Yorkers. The boat landing continued to host many Hudson River day-liners, even after the region became accessible to automobile travel with the opening of the Bear Mountain Bridge.

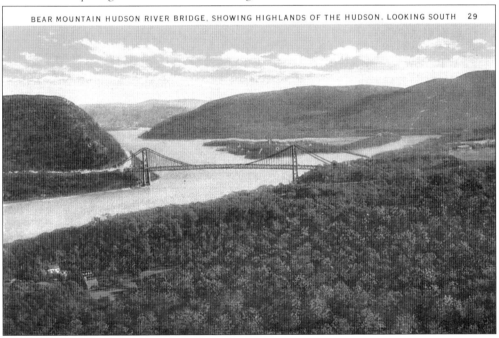

BEAR MOUNTAIN HUDSON RIVER BRIDGE, SHOWING HIGHLANDS OF THE HUDSON, LOOKING SOUTH 29

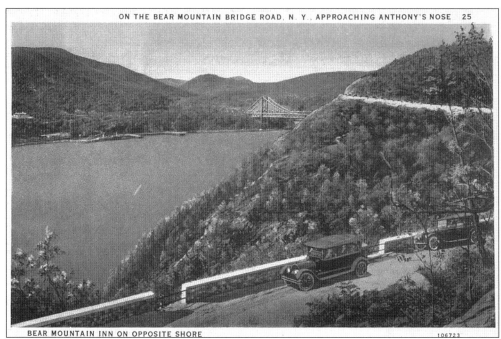

BEAR MOUNTAIN INN ON OPPOSITE SHORE 106723

Near Bear Mountain is another peak with a picturesque name, Anthony's Nose, which the explorer Estevan Gomez called St. Anthony's Nose on his charts. In the distance is the new Bear Mountain Bridge and Bear Mountain Inn. The bridge's tollhouse is picturesque and worthy of the American Rhine. Nearby, on the bluff, just south of the tollbooths, is the site of the American Revolution's Fort Clinton.

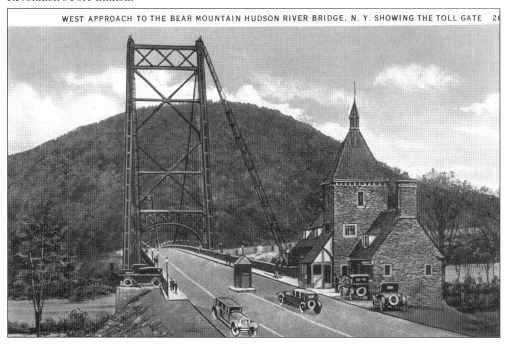

WEST APPROACH TO THE BEAR MOUNTAIN HUDSON RIVER BRIDGE, N. Y. SHOWING THE TOLL GATE 26

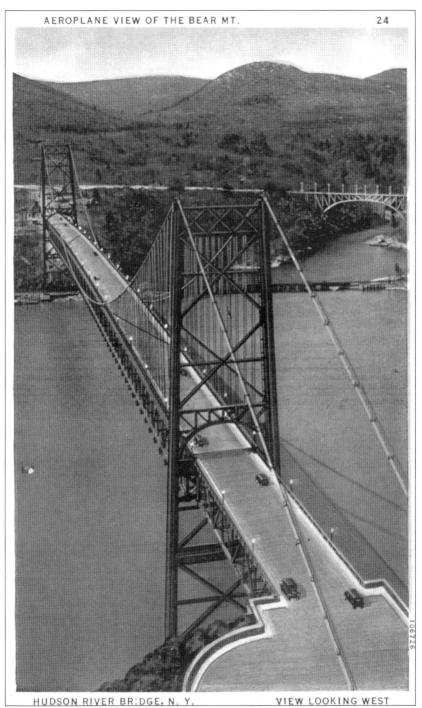

HUDSON RIVER BRIDGE, N. Y. VIEW LOOKING WEST

When the Bear Mountain Bridge was built in 1924, it was the world's largest suspension bridge, with a span of 1,632 feet. The huge cables are 18 inches in diameter and each is spun from 7,252 wires. Designed by Howard Baird and built as a privately financed project, the bridge cost $5 million. In 1940, the bridge was acquired by New York State for $2.3 million. Like other Hudson River crossings, it remains a toll bridge.

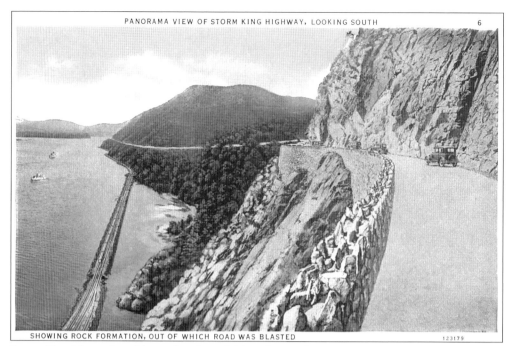

SHOWING ROCK FORMATION, OUT OF WHICH ROAD WAS BLASTED 123179

Storm King Mountain, with an elevation of 1,340 feet, is the northeastern buttress of the Hudson Highlands. The Old Storm King Highway, shown here when new in the 1920s, was widely considered to be an engineering marvel, as it traverses the cliffs above the river at approximately 200 feet and provides magnificent vistas. In 1940, a new and straighter Storm King Highway was built farther inland, offering more limited views. In the Hudson Highlands, a government report notes that you find the only place where a "river cuts the Appalachians at sea level . . . [and] creates river scenery of unequaled scale."

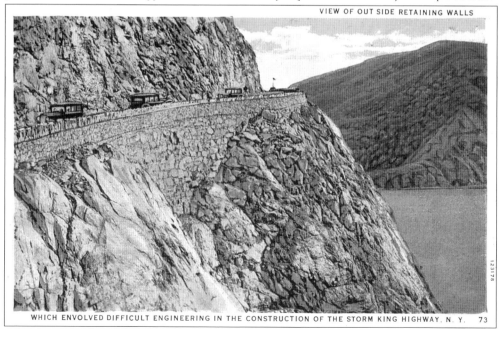

VIEW OF OUT SIDE RETAINING WALLS

WHICH ENVOLVED DIFFICULT ENGINEERING IN THE CONSTRUCTION OF THE STORM KING HIGHWAY. N. Y. 73

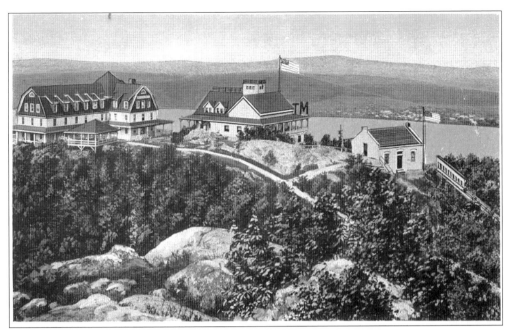

Mount Beacon actually has two summits: North Beacon, with an elevation of 1,531 feet, and South Beacon, with an elevation of 1,635 feet. They are the highest points between the Catskills and the Atlantic Ocean. Mount Beacon takes it name from beacon fires, used as signals during the Revolution. The Mount Beacon Incline Railroad opened in May 1902. The average gradient of this steep cable railroad is 64 percent. By the 1920s, there was a casino, above, new when the railroad was opened, a hotel, and several summer homes that are not visible here. Climbing or descending Mount Beacon on the train was very popular, as shown in the *c.* 1905 card below.

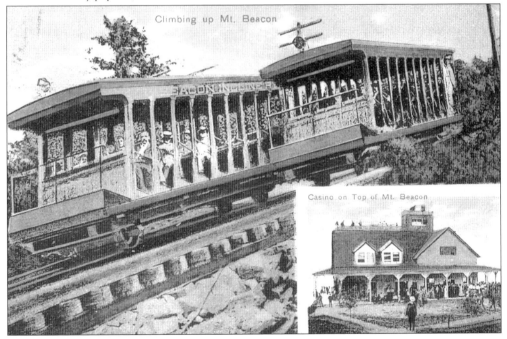

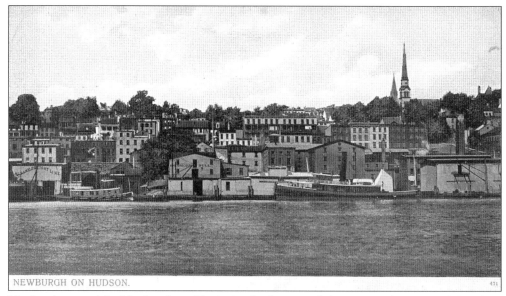

NEWBURGH ON HUDSON.

Newburgh, named for Newburgh-on-Tay in Scotland, was a whaling port and a center of the China trade in the early 19th century. By the 1840s, Newburgh was a major manufacturing and shipbuilding center. With the money came art, and Newburgh was the home of the famed landscape designer Andrew Jackson Downing. Some say that Hudson River bracketed architecture is indigenous to Newburgh, which is set in a beautiful riverine location. These cards, *c.* 1906, show a busy, prosperous community with a beautiful park.

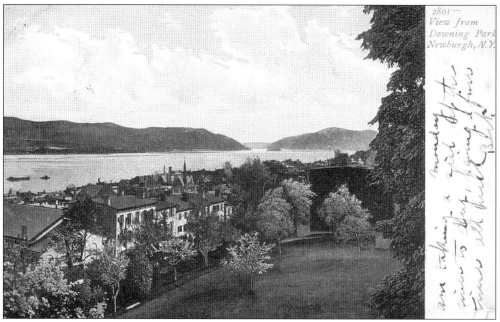

50

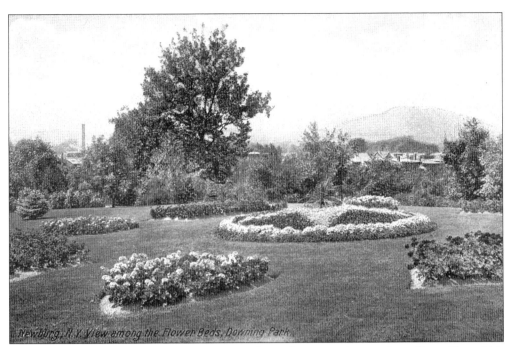

Newburg, N.Y. View among the Flower Beds, Downing Park.

Andrew Jackson Downing was killed in 1852 in the explosion on the steamboat *Henry Clay*, which occurred while the captain raced another Hudson steamer. The American garden and landscape community was shocked. Downing's nursery adjacent to his home, Highland Garden, in Newburgh, supplied plants to many Hudson River estates, including Lyndhurst, Montgomery Place, and Blithwood. Downing was, in addition, a significant national taste-maker, through his many books and articles on architecture and horticulture. Downing Park, overlooking the Hudson, is shown in these *c.* 1905 cards. It was designed by New York City's Central Park creators Calvert Vaux and Frederick Low Olmstead as a tribute to Downing, who was their friend.

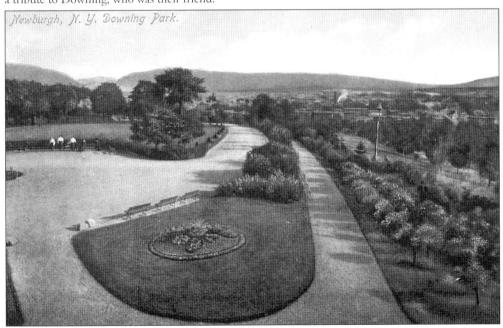

Newburgh, N. Y. Downing Park.

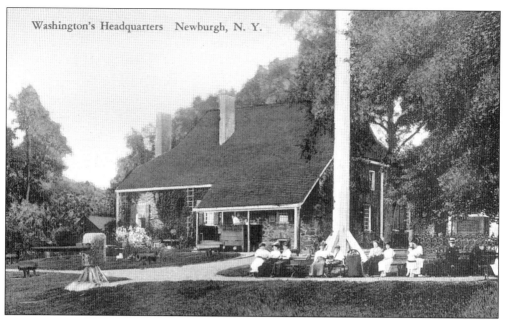

Washington's Headquarters Newburgh, N. Y.

George and Martha Washington lived in the Jonathan Hasbrouck House from April 4, 1782, to August 18, 1783. Hasbrouck, a Huguenot, acquired the Dutch house in 1750 and subsequently enlarged the 1724 structure. In 1850, New York State purchased the home from the Hasbrouck family, marking the first time any governmental agency made a commitment to historic preservation. The Tower of Victory, below, was designed by John H. Duncan of New York City and was built in 1888. A government report in 1889 announces that the view "embraces a broad expanse of river and mountain scenery. . . . North and South Beacon, upon whose towering tops the signal fires were lit during the Revolution, are directly in front, whilst to the right will be seen the Northern Gate to the Highlands and West Point in the distance."

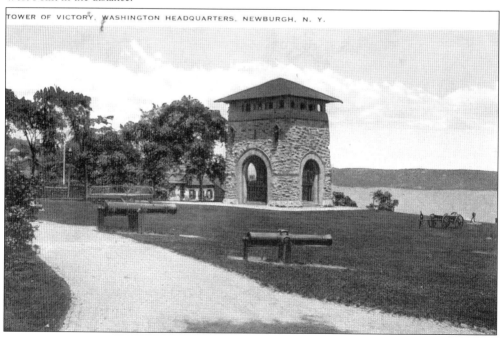

TOWER OF VICTORY, WASHINGTON HEADQUARTERS, NEWBURGH, N. Y.

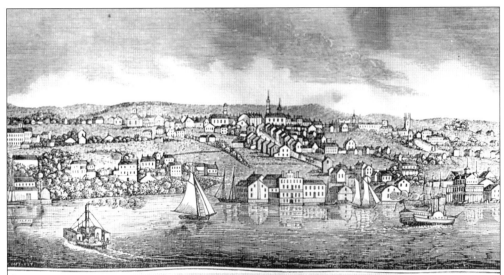

WESTERN VIEW OF POUGHKEEPSIE, N. Y.

The above shows the appearance of Poughkeepsie, as seen from the elevated bank on the west side of the Hudson, a short distance below New Paltz landing. The Hotel at the Steamboat landing, is seen on the extreme right.

Poughkeepsie was called the "Queen City of Hudson" because of its beautiful site and economic prosperity. In 1808, the opening of the Duchess Turnpike from Poughkeepsie to Sharon, Connecticut, resulted in considerable inland commerce. According to historian Benson J. Lossing, the name Poughkeepsie is derived from the Mohegan words *Apo-keep-sinck*, meaning "safe and pleasant harbor." These 1940s postcards reproduce prints of pre-Civil War Poughkeepsie and emphasize the community's relationship to the river. George Polk's Poughkeepsie Marine Railways Yacht and Shipbuilding Yard is testimony to the long coexistence between steam and sail on the river.

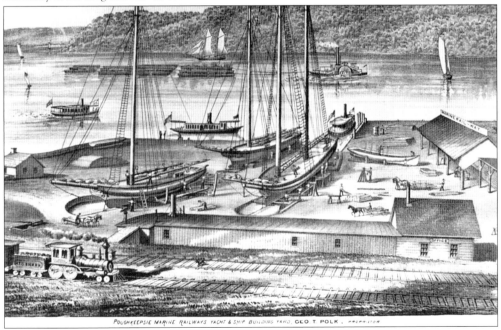

POUGHKEEPSIE MARINE RAILWAYS YACHT & SHIP BUILDING YARD, GEO. T. POLK, PROPRIETOR

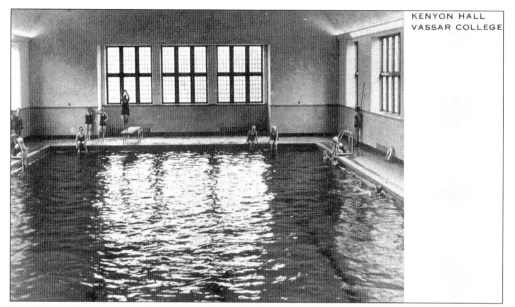

KENYON HALL
VASSAR COLLEGE

Poughkeepsie's internationally known Vassar College was founded in 1861 by Matthew Vassar (1792–1868), a very successful brewer. The school was known as Vassar Female College, a place where "women can learn what is useful, practical and sensible." The photograph for the 1920s view of women swimming in the pool at Kenyon Hall was taken by Margaret De. M. Brown. Today, Vassar is nominally coeducational.

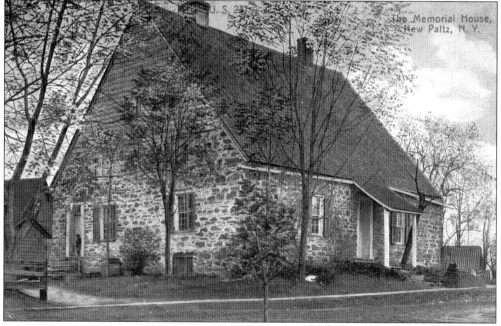

In 1677, the *Douzine* (Twelve Men) purchased a large tract of land from the Esopus Indians, inland from the Hudson. This all-Huguenot group named the land New Paltz in honor of the palatinate or Nie Pfalz in Germany, which had given them refuge before they came to America. The Abraham Hasbrouck House was the first home of a Douzine member to be preserved as a museum. Today, Huguenot Street in New Paltz is an outdoor museum.

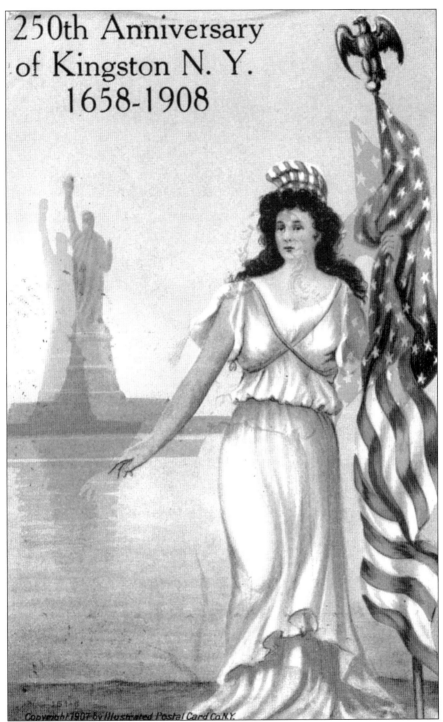

250th Anniversary
of Kingston N. Y.
1658-1908

Copyright 1907 by Illustrated Postal Card Co.N.Y.

Because it was founded as a stockaded town by order of Peter Stuyvesant in 1658, Kingston, originally known as Wiltwyck (Wild Place), could start its celebrations a year before the Hudson-Fulton events. In 1908, Mary writes, "Something doing all the time [here]." The iconography of the card is interesting, juxtaposing the Statue of Liberty and the emblematic Miss Liberty without any visual tie to Kingston.

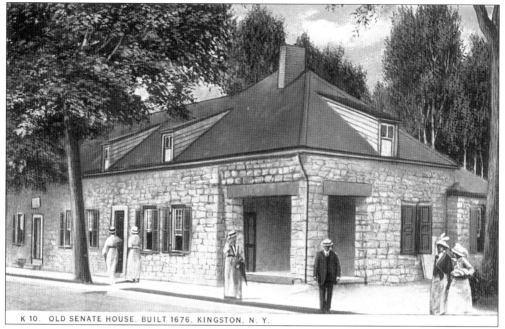

K 10. OLD SENATE HOUSE, BUILT 1676, KINGSTON, N. Y.

The town of Wiltwyck became Kingston in 1679. During the French and Indian War (1754–1763), Kingston was a base for military operations on the frontier. Its Dutch character has remained strong. Kingston's Dutch Reformed Church, organized in 1659, is considered the mother church of the Dutch Reformed movement in America. During the Revolution, Kingston was the capital of New York State and the first meeting place of the New York Senate, in 1777. Both the Old Senate House and Old Von Sternburg House are Dutch homes. The Von Sternburg House had been Victorianized with the roof dormer. The Senate House has been a museum since 1887.

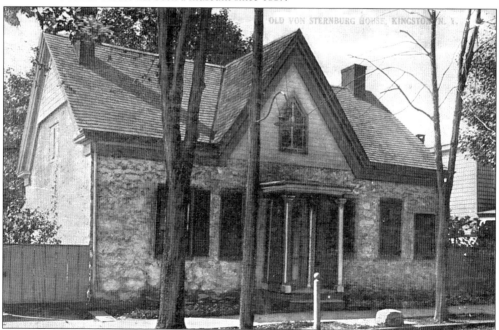

56

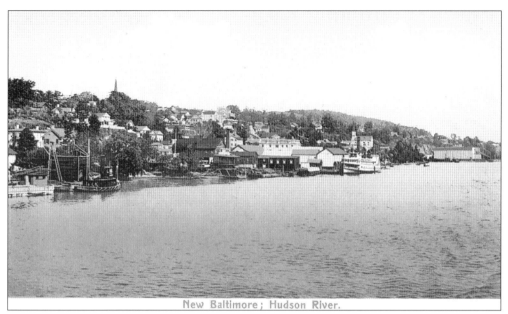

New Baltimore; Hudson River.

While located miles apart, both New Baltimore and Fishkill-on-Hudson (incorporated into Beacon since 1913) are typical of the small towns along the river, having boat activity on their riverfront and rising on a gentle slope from the water. Both towns are crowned by church steeples. Fishkill takes its name from Vischer's Kil, or Fisherman's Creek, which flows into the Hudson. The present independent village of Fishkill is two miles inland and incorporates the towns of Glenham and Wolcottville. New Baltimore had a large sloop- and barge-building industry. The movie *Little Old New York*, starring Alice Faye and Fred MacMurray, was filmed there in 1939. The cards both date from *c.* 1910.

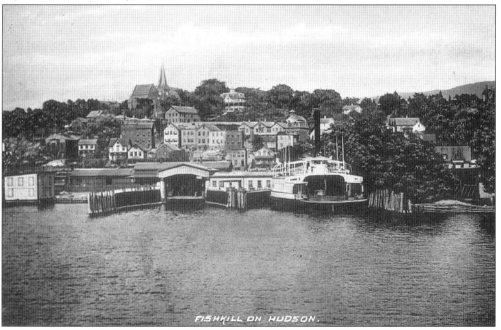

FISHKILL ON HUDSON.

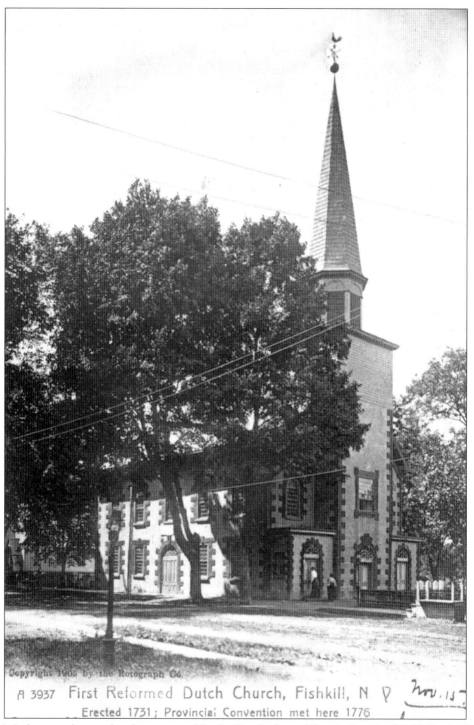

A 3937 First Reformed Dutch Church, Fishkill, N Y

Erected 1731; Provincial Convention met here 1776

This is the second stone church constructed by the First Reformed Dutch Church of Fishkill. The first stone church was a simple square building with a central belfry mounted on the roof. The building shown here was constructed in 1731 and was subsequently remodeled. It is typical of many Dutch churches in the region.

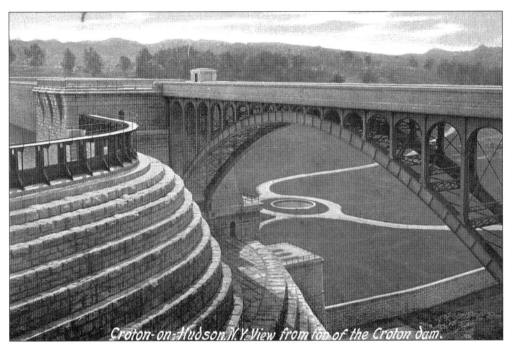

Croton-on-Hudson, N.Y. View from top of the Croton dam.

Water from the Hudson's tributaries is vital to New York City. In nearby Westchester County, the Croton River was dammed as early as 1837 and a stone aqueduct was built to carry water to the growing city. The dam shown above was built between 1884 and 1890. Farther north, New York's need for water has changed the face of the Catskills. The Ashokan Reservoir was begun in 1906, and water from the Esopus Creek started to fill it in 1915. In later years, the Rondout Creek, yet another Hudson tributary, was also dammed.

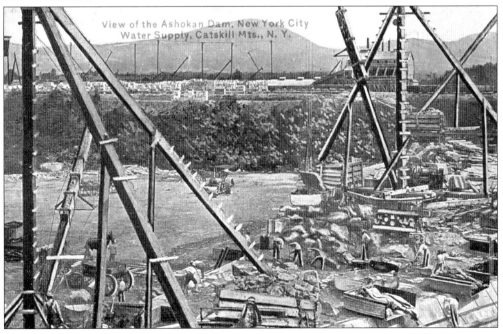

View of the Ashokan Dam, New York City Water Supply, Catskill Mts., N. Y.

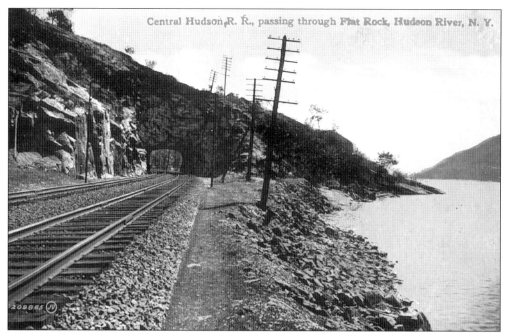

The railroad made great changes along the "American Rhine," as it did along its European namesake. This *c.* 1905 card shows the Central Hudson Railroad's tracks passing through Flat Rock, near Peekskill. Telegraph, telephone, and power lines often shared railroad rights of way.

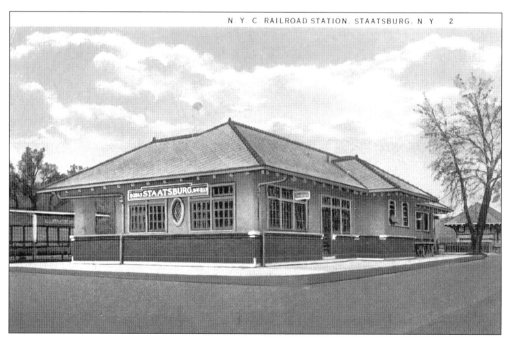

The New York Central Railroad Station at Staatsburg was typical of the many fine, small stations that served the Hudson Valley towns that were also the seats of great estates. The nearby Mills Mansion, a magnificent establishment, was the model for the Hudson Valley estate described in Edith Wharton's novel *The House of Mirth*.

Three
TRAVEL THE BEAUTIFUL RIVER

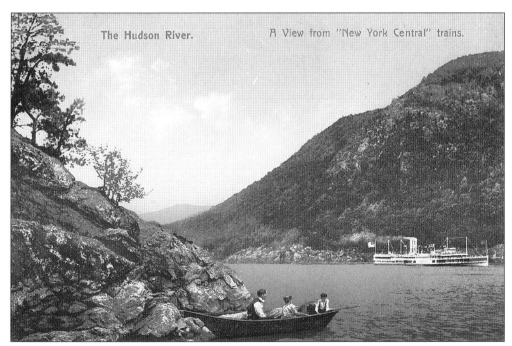

Passengers on an unseen New York Central train witnessed this view *c.* 1905. It lacks only a sailboat for completeness. In the foreground, three fishermen, presumably locals, sit in a rowboat; in the distance, an excursion boat, proudly flying the American flag, steams through the picturesque Hudson Highlands.

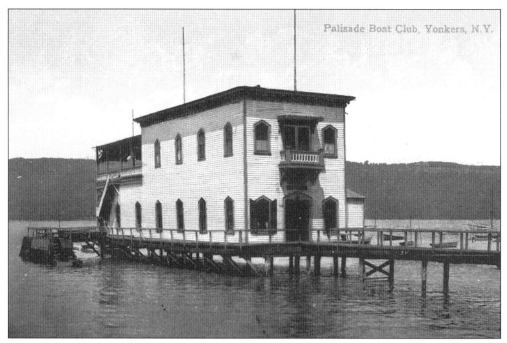

Palisade Boat Club, Yonkers, N.Y.

Boating, be it for pleasure or transportation, is synonymous with the Hudson River. Pleasure craft, boat clubs, and marinas have been a river feature for well over a century. Many boat clubs were actually built on piers that extended into the river. The above, *c.* 1890s structure in Yonkers, where the Saw Mill River joins the Hudson, is a good example of these piers, as is the earlier, and more elaborate, Hunter Club Boat House at Nyack, which was probably built in the 1870s. Boats were apparently being readied for a regatta: note the flags. Both views are from *c.* 1910.

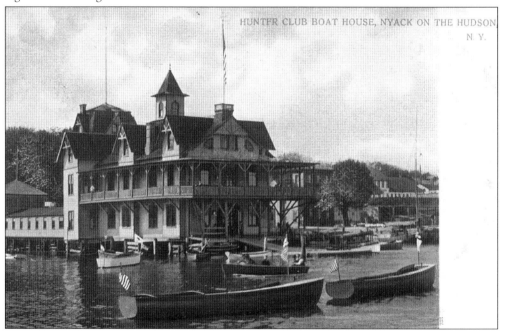

HUNTER CLUB BOAT HOUSE, NYACK ON THE HUDSON, N. Y.

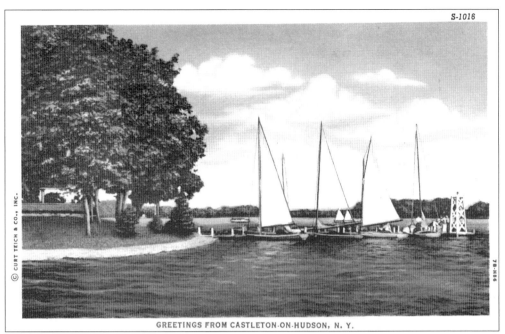

S-1016

7B-H86

GREETINGS FROM CASTLETON-ON-HUDSON, N. Y.

Pleasure boats, like these sailboats at Castleton-on-Hudson c. 1940, could intimately explore the riverbank. Castleton-on-Hudson was settled c. 1630. The town was built on steep banks, which gave it a castlelike appearance that led to its name. Sights like the 18th-century Houtaling Farm House below, built by descendants of a Dutch family on Four Mile Point, could best be seen from small craft. The Central Hudson region, where these sights are located, is always changing. The New York Thruway Bridge, which carries the road to a connection with the Massachusetts Turnpike, now crosses at Castleton-on-Hudson.

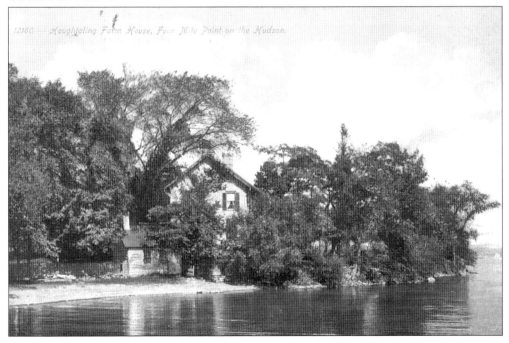

12150 Houghteling Farm House, Four Mile Point on the Hudson.

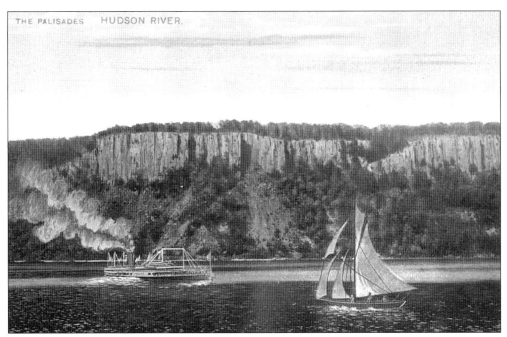

The Palisades is a great geological formation that extends along the West Bank of the Hudson from behind Jersey City to just south of Sneden's Landing. The name Palisades derives from the walls of fortification that the cliffs fancifully resemble. Early vacationers were mainly upper-class and upper middle-class Americans. Hudson River excursion boats opened the one-day vacation experience to working-class and lower middle-class New Yorkers, as well. Below, stylishly dressed day-trippers scramble over the Palisades, across the river from Hastings-on-Hudson, while their boat waits near one of the many piers on the Hudson.

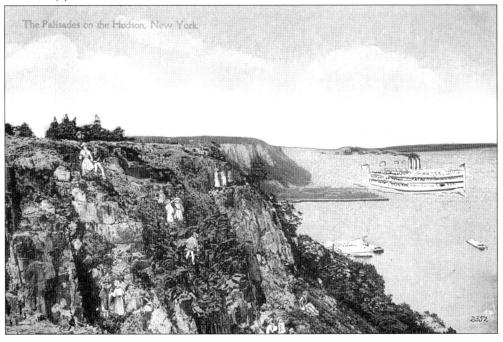

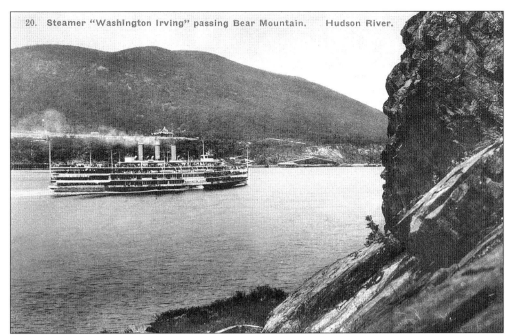

20. Steamer "Washington Irving" passing Bear Mountain. Hudson River.

The majesty of Bear Mountain looming above the broad, impressive "American Rhine" was one of the most popular scenic spots on the river for both day-trippers and those heading upriver to the Capital Region or beyond by taking advantage of the canal system. The three-stack steamer *Washington Irving* was named for the great 19th-century writer, who lived overlooking the river in Tarrytown and who wrote many tales about the Hudson and the Catskills.

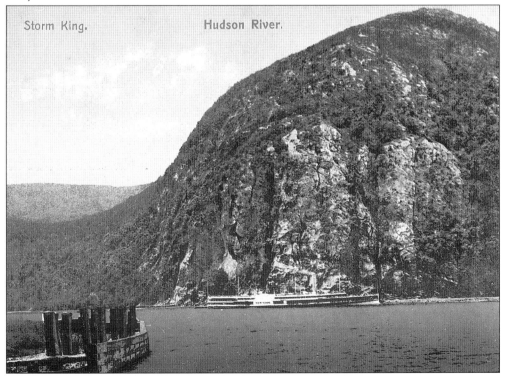

Storm King. Hudson River.

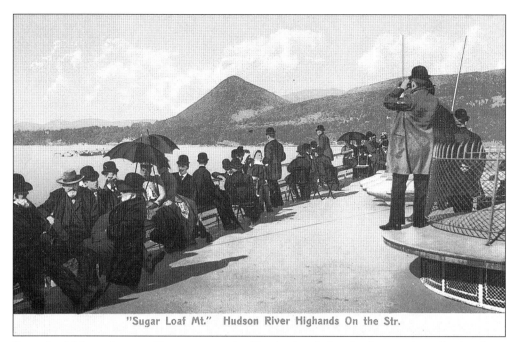

"Sugar Loaf Mt." Hudson River Highands On the Str.

Sugar Loaf Mountain, near Beacon, was a familiar landmark for riverboat cruisers. In the above photograph *c.* 1910, we see a cross-section of well-dressed excursionists. The eager man on the right looks at the scenery through binoculars. while the group of men on the left appear indifferent to their glorious surroundings. Clearly, however, a trip on the Hudson River was an event. In the lower card, several women are shown using parasols. It was not until the end of the 1920s that it became fashionable for women to have suntans.

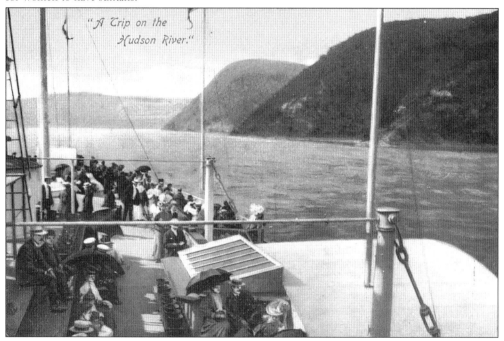

"A Trip on the Hudson River."

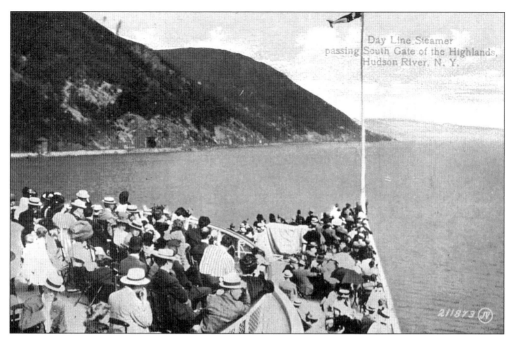

Everyone appears very attentive as the *Day Liner Steamer* passes the south gate of the Highlands. Note the large hats that the ladies are wearing in this 1910 view. In the lower card, a woman has apparently removed her headgear. Hats for both men and women was almost mandatory. Gus, from Brooklyn, writing to Miss Alice Johnson, also of Brooklyn, on May 6, 1908, states: "Alice once again we are sailing up to Mt. Beacon. I saw the boat at the dock yesterday and it made me long for the chance to go again."

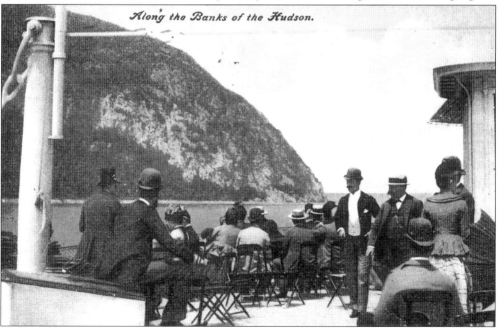

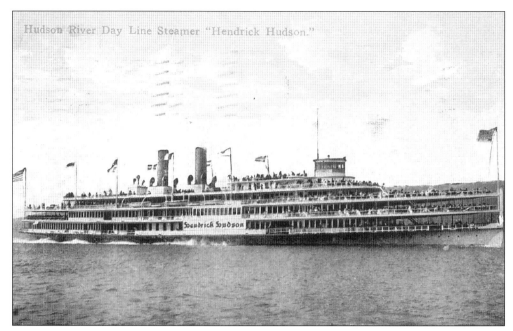

Excursion boats often used names that were derived from the Dutch colonial past. What could be more fitting than to cruise up the Hudson River on the *Hendrick Hudson*, named for the river's explorer? The steamer *Peter Stuyvesant* of the Hudson River Day Line, was named for the last Dutch governor of the New Netherlands. The *Hendrick Hudson* was built at the Marvell Shipyard in Newburgh, as were the *Robert Fulton* and the *Alexander Hamilton*.

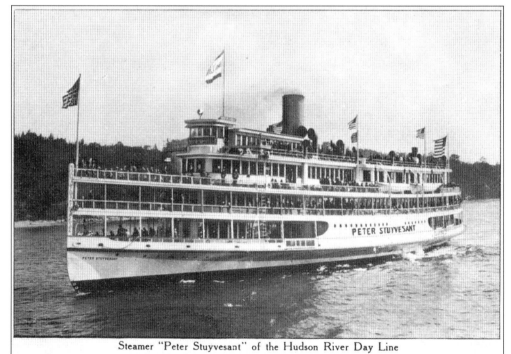

Steamer "Peter Stuyvesant" of the Hudson River Day Line

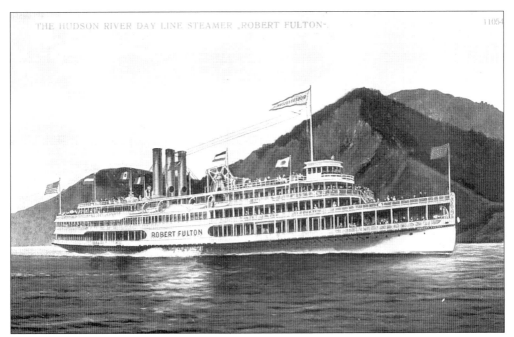

Hudson River Day Liners were often palatial ships that could accommodate thousands of passengers. They had restaurants and also orchestras. They were cruise ships for the masses. Most stopped at a near destination like Bear Mountain where passengers would leave the boat for a day picnicking, strolling, or enjoying sports before the return trip to the city. The *Robert Fulton* was named for the inventor of the steamboat. The *Alexander Hamilton* was named for George Washington's secretary of the treasury, who had a home overlooking the Hudson and who died as the result of a duel held at Weehawken, also in sight of the river.

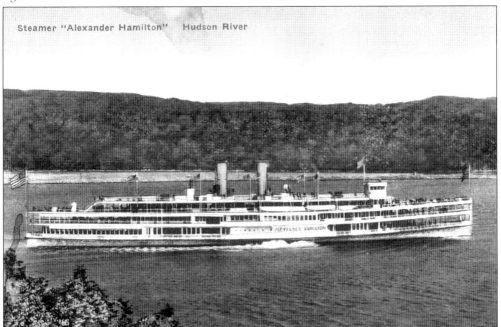

Steamer "Alexander Hamilton" Hudson River

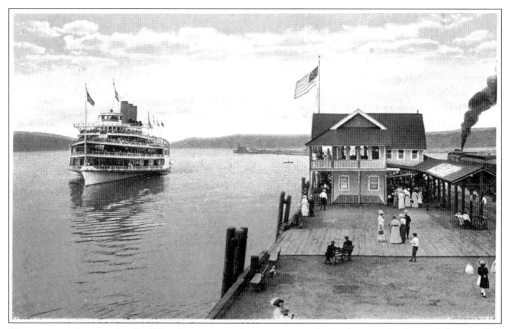

Kingston, on the west bank of the river, was an important stop for both excursionists and for travelers who changed to a train for one of many Catskill Mountain destinations. As a boat came in, a number of people waited to greet newcomers. After the boat arrived, the dock became crowded. Trains awaited passengers. The automobiles shown below probably belonged to the various Catskill resorts, which sent drivers to meet newly arriving guests. Resort owners recount anecdotes stressing the importance of meeting their guests promptly before a rival resort "kidnapped them away." As a young girl in the 1920s, the author's mother remembers starting her first visit to the Catskills in Kingston. Except for the clothing, the scene was probably little changed from the one in these *c.* 1910 postcards.

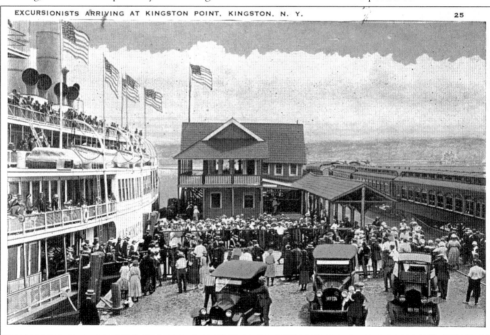

EXCURSIONISTS ARRIVING AT KINGSTON POINT, KINGSTON, N. Y. 25

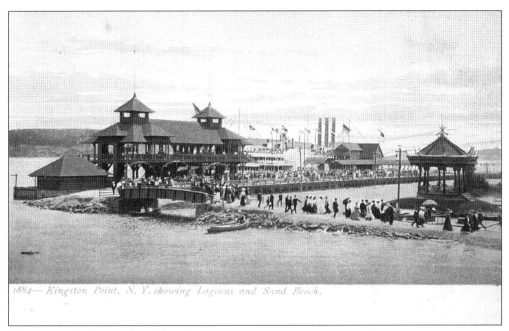

1884 — Kingston Point, N. Y. showing Lagoons and Sand Beach.

Historically called Columbus Point, Kingston Point was an important river landing and a transfer point where passengers would board trains of the Ulster and Delaware Railroad for trips into the Catskills. For many years the Hudson River Day Lines maintained pleasure grounds on the river, as modern cruise companies do on their private islands in the Caribbean. Here day-trippers could picnic, dance, rowboat, swim, or bathe before reboarding the steamer for the return trip to New York City. The site today is shared by a public park and an oil depot.

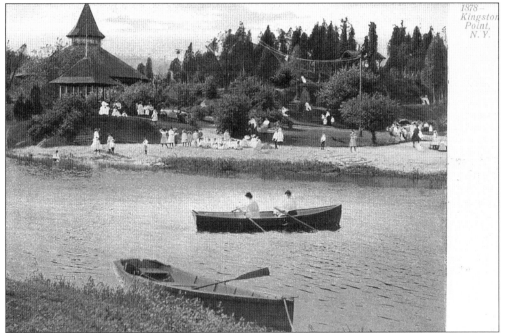

1878 — Kingston Point, N. Y.

71

Catskill, New York, was a stop for New Englanders making the trek west who first had to ferry across the river from Hudson on the east shore. Catskill was a center for the tanning industry and the landing spot for many visitors to the Catskill Mountain House, the pioneer Catskill luxury resort. The town was the adopted home of Thomas Cole, the founding father of the Hudson River school of painters. For years, Catskill was a significant landing for both the Hudson River Day Line as well as the lesser known Night Line. The final Day Line boat docked in Catskill in 1953. The Hudson-Catskill Ferry was always very busy. Today, the two communities are linked by the Rip Van Winkle Bridge.

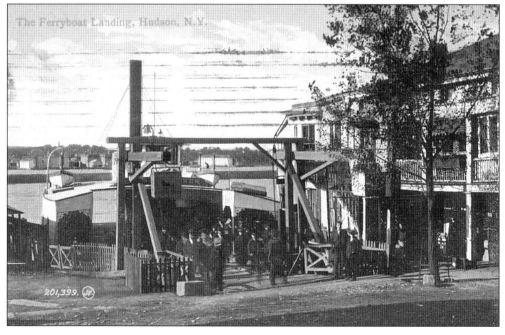

The Ferryboat Landing, Hudson, N.Y.

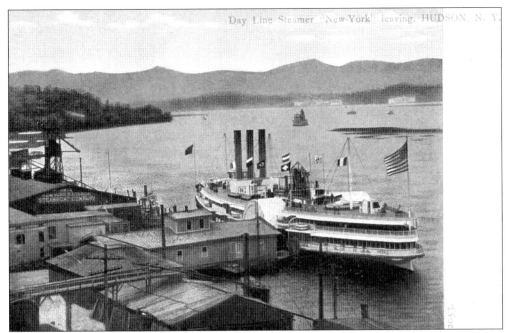

Hudson, the seat of Columbia County, was first settled by the Dutch, but the city was founded in 1784 by New Englanders, including many Quakers from Nantucket Island and Providence. In 1785, Hudson became the third city to be charted by New York State. Because of its New England maritime heritage, Hudson became an important whaling center. In 1790, it became an official seaport, with resident customs officers and government seals. In later years, it was a railroad terminal, a stop on the Hudson River Day Line, and the center of light manufacture. Today, the town is the antiquing mecca of the Hudson Valley. Antique shops line the public square, which looks much as it does in this *c.* 1905 view.

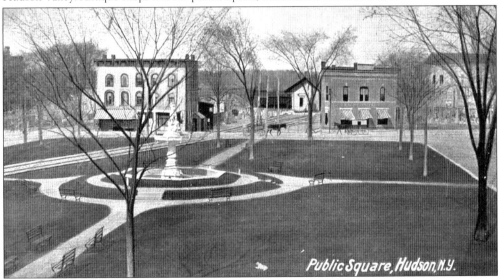

Public Square, Hudson, N.Y.

The Hudson River School of landscape painting was born in the river valley with Thomas Cole (1801–1848), who settled in Catskill in the 1830s. His greatest student, Frederick Edwin Church (1826–1900), who was born in Hartford, Connecticut, became America's first internationally known landscape artist. He built a phenomenal home named Olana high on a hill overlooking the Hudson, which is a museum today. The artists were intrigued by the many moods of the river and its sailboats. It is a cliche in the art world today to call almost any painting that includes a sailboat on a river a Hudson River school painting. The school's members also favored paintings with streams and cattle. Cows were an important symbol of domesticity. Albany's Clinton Loveridge (1824–1902) was especially known for his cattle-enhanced landscapes.

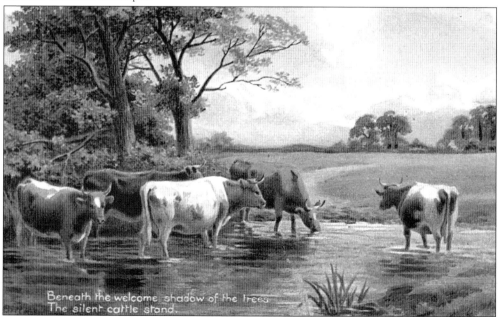

Beneath the welcome shadow of the trees
The silent cattle stand.

Four

FANTASY AND LEGEND

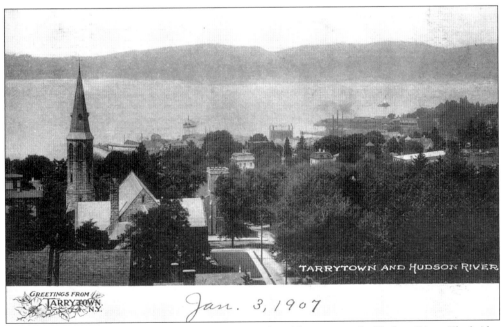

GREETINGS FROM TARRYTOWN. N.Y.

Jan. 3, 1907

Tarrytown faces towards the Tappan Zee Bridge. It is the widest spot on the Hudson River. The bridge is 12 miles long and 2 to 2.4 miles wide. The name is a composite of cultures. Tappan is derived from an Indian word for cold springs. Zee is the Dutch word for sea. Tarrytown probably derives its name from *Otarwe*, the Dutch word for wheat. Washington Irving tells us that it got its name because local Dutch farmers "would tarry" at local taverns when they came to market. His definitions were always more colorful and more fun.

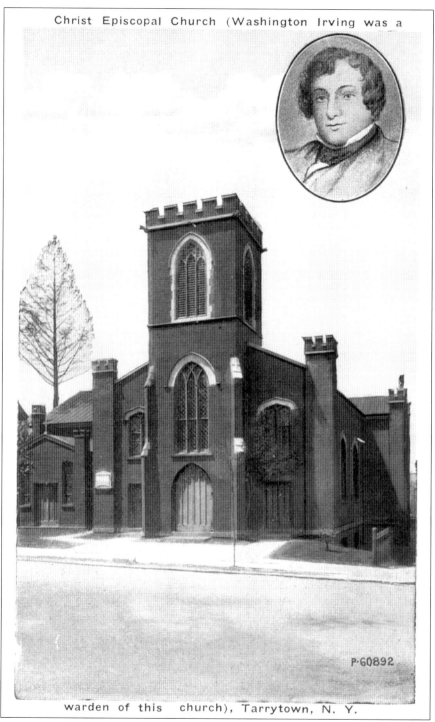

Christ Episcopal Church (Washington Irving was a warden of this church), Tarrytown, N. Y.

P·60892

The small, red brick, Gothic Revival-style Christ Episcopal Church, built in 1838, was a perfect fit for the "American Rhine" and for the romantic soul of Washington Irving, who worshiped here from 1843 to 1859. He was a warden of the church built on land that had been part of the Philipse Manor. His funeral was held here.

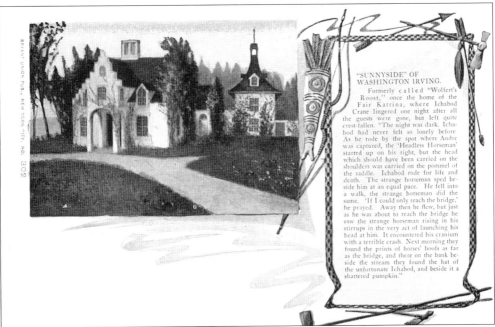

"SUNNYSIDE" OF WASHINGTON IRVING.

Formerly called "Wolfert's Roost," once the home of the Fair Katrina, where Ichabod Crane lingered one night after all the guests were gone, but left quite crest-fallen. "The night was dark. Ichabod had never felt so lonely before. As he rode by the spot where Andre was captured, the 'Headless Horseman' started up on his right, but the head which should have been carried on the shoulders was carried on the pommel of the saddle. Ichabod rode for life and death. The strange horseman sped beside him at an equal pace. He fell into a walk, the strange horseman did the same. 'If I could only reach the bridge,' he prayed. Away then he flew, but just as he was about to reach the bridge he saw the strange horseman rising in his stirrups in the very act of launching his head at him. It encountered his cranium with a terrible crash. Next morning they found the prints of horses' hoofs as far as the bridge, and there on the bank beside the stream they found the hat of the unfortunate Ichabod, and beside it a shattered pumpkin."

With the profits from his writings—including those that introduced America to Ichabod Crane, the Headless Horseman, and Rip Van Winkle—Washington Irving, in collaboration with his friend Richard William Hubbard (1817–1888), converted a 17th-century Dutch farmhouse that had been owned by Jacob Van Tassel into a fantastic estate. Between 1835 and 1837, Irving remodeled the house he originally called Wolferts Roost into a fantasy replete with Holland Dutch, Spanish, Gothic, and Chinese overtones. It remained his home until his death in 1859. Preserved by the niece whom he raised, the home was restored by Sleepy Hollow Restorations (now Historic Hudson Valley), which now shows it as a museum.

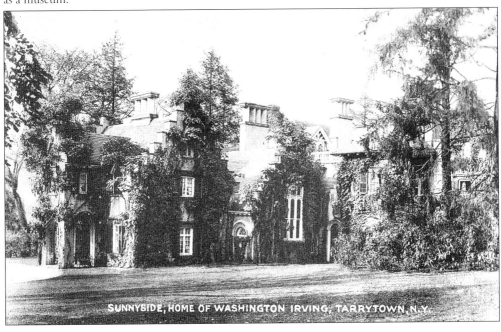

SUNNYSIDE, HOME OF WASHINGTON IRVING, TARRYTOWN, N.Y.

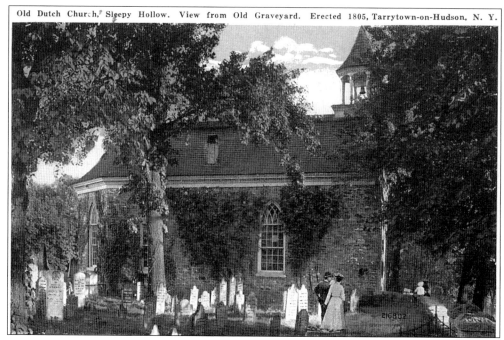

The Old Dutch Church at Sleepy Hollow, according to a handwritten message on the back of the top card "was built by Frederick Filipse [Philipse] and his wife Katrina Van Cortland, 1690. Around the church are the oldest graves with unique inscriptions." There is a Katrina Van Tassel buried in the churchyard. The hapless Ichabod Crane met the Headless Horseman as he passed the graveyard. These c. 1910 cards of the exterior and interior of the church were published by the Tarrytown Postcard Company.

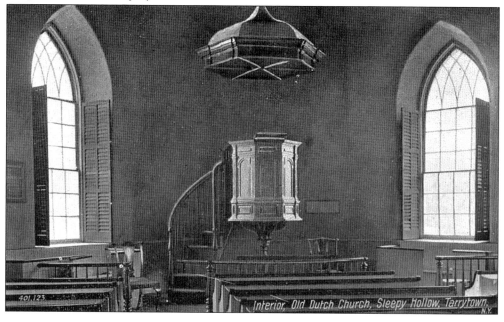

Washington Irving Memorial Bridge, Sleepy Hollow, Tarrytown, N. Y.

Many people visit Tarrytown today, as they have since the mid-19th century, to see the sites where Ichabod Crane fled from the Headless Horseman, who threw his jack-o-lantern head at the unfortunate schoolmaster. The apple of Ichabod's ever-hungry eye was Katrina Van Tassel, the daughter of a rich Dutch farmer. Her alleged home was subject enough for an early 20th-century postcard.

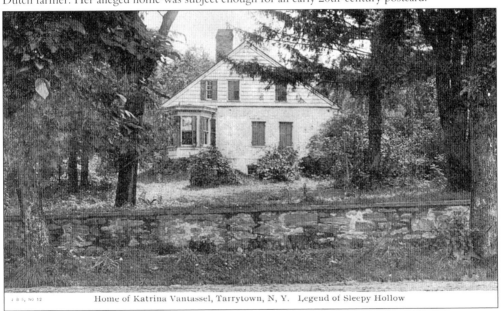

Home of Katrina Vantassel, Tarrytown, N, Y. Legend of Sleepy Hollow

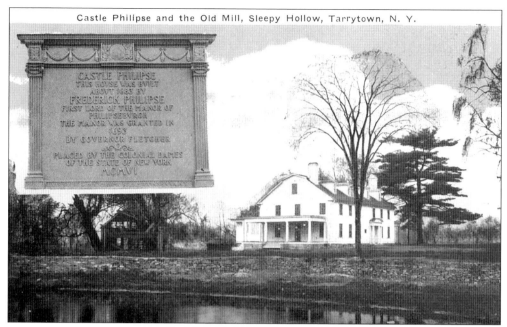

Castle Philipse and the Old Mill, Sleepy Hollow, Tarrytown, N. Y.

Much legend, as well as history, revolved around these remnants of the great Philipse Manor in northern Westchester County, located on the Croton River, near where it flows into the Hudson. Both the mill and the manor house were supposedly haunted. Known as the Upper Mills, the site was developed in the late 17th century and was operated mostly by black slaves. In 1784, the property was bought at auction by Gerard Beekman. Upon his death, the manor house and mill were separated from the lands and sold individually. After passing through many hands, they were in danger of being demolished when they were saved by John D. Rockefeller Jr. in 1937. Rockefeller formed Sleepy Hollow Restorations to restore and preserve them.

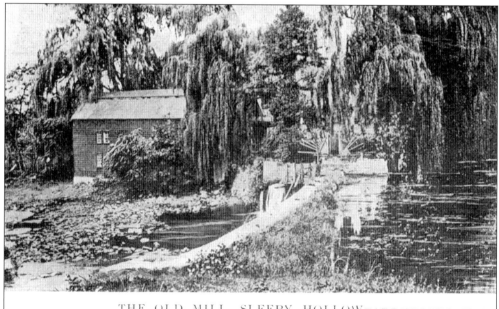

THE OLD MILL, SLEEPY HOLLOW TARRYTOWN, N. Y.
Copyright, 1904, P. A. Weber, Tarrytown, N. Y.

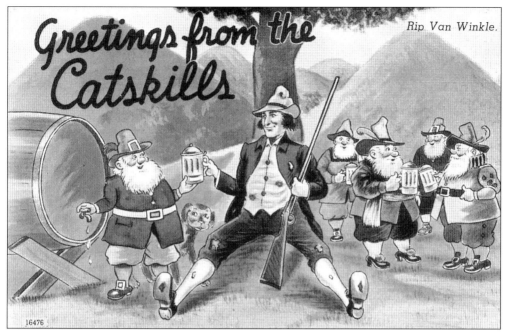

The legend of Rip Van Winkle jumped from the short story by Washington Irving (1783–1859) into the national consciousness. Unlike *The Legend of Sleepy Hollow*, this tale is set in the Catskills, high above the river. Fleeing from his shrewish wife, Rip drinks a magic potion and falls asleep for 20 years. Catskill Mountain tourism has adopted his story and has exploited it for almost two centuries. It was even translated into Yiddish. As early as 1832, the already legendary Rip Van Winkle had been given a specific geographical home near the great resort, the Catskill Mountain House. A single-room shanty existed on this spot from *c.* 1828. By the 1860s, a Rip Van Winkle was living here, selling refreshments. Both cards date from *c.* 1905.

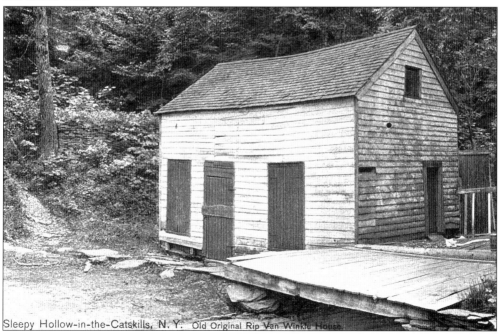

Sleepy Hollow-in-the-Catskills, N. Y. Old Original Rip Van Winkle House.

81

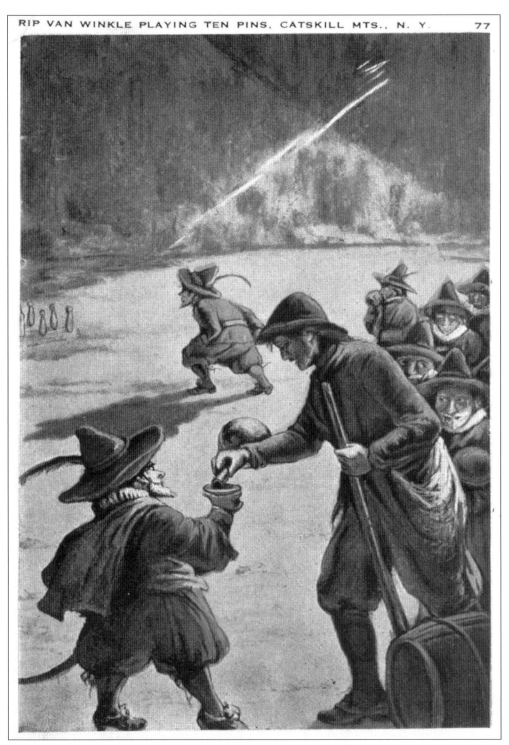

Wandering in the Catskills after his argument with his wife, Rip Van Winkle discovered the source of Catskill Mountain thunder: Henry Hudson's crew bowling tenpins. Good-natured Rip joins in their revelry, shares their drink, and falls into a deep sleep.

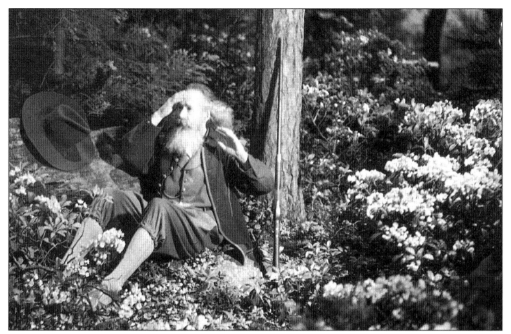

Rip Van Winkle's great sleep lasted from 1774 to 1794. For many years the awakening has been reenacted at Rip's Retreat, a tourist attraction at Haines Falls in the Catskills. Below, elderly Rip stands in front of the theatrical Dutch *keuken,* or kitchen, in the presence of "youth and maidens in authentic Dutch costumes of the 18th century on the Bowling Green." The costumes, of course, owe more to fantasy than to Holland, especially when you note the short lengths shown on this 1950s card.

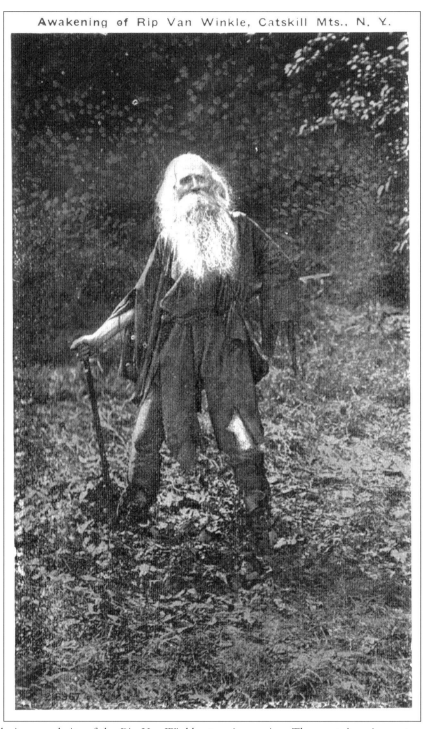

Awakening of Rip Van Winkle, Catskill Mts., N. Y.

The enduring popularity of the Rip Van Winkle story is amazing. The great American actor Joseph Jefferson (1829–1905) toured America for more than 50 years, playing Rip. His performances virtually always sold out. In his later years, he looked remarkably like the image on this card, published in Brooklyn *c.* 1920.

84

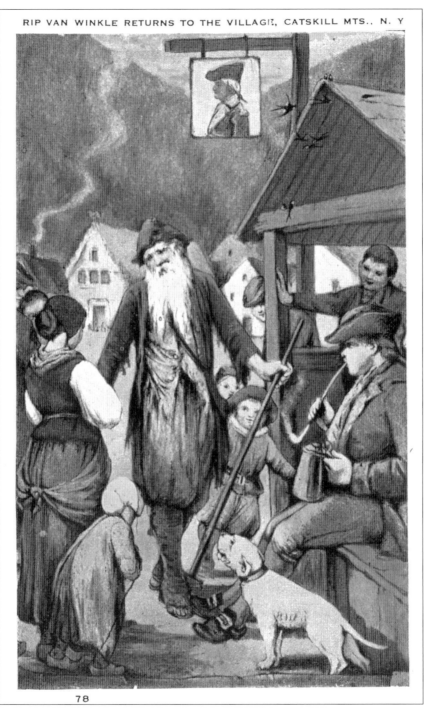

78

As the Rip Van Winkle legend was enhanced, Catskill on the Hudson was claimed as his birthplace. When he returned home after his sleep, he was looked upon as a curiosity, but then he learned that all of his problems were solved: his wife was dead and his little daughter, now grown, wanted to take care of her long-absent father, whom she had always loved. Here, a bewildered Rip discovers that George III is no longer his king, but George Washington is president.

85

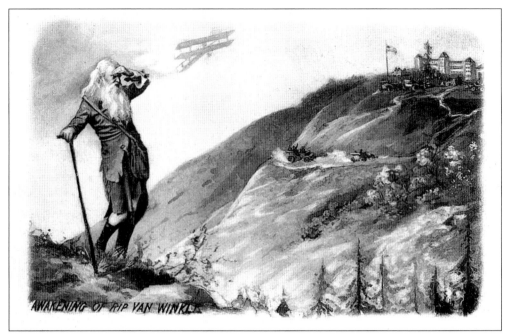

The author's favorite "Awakening of Rip Van Winkle" is this 1920s version, published in New York City. It shows Rip waking up in the 20th-century Catskills. A biplane circles, and automobiles head up the mountain, which is topped by a great, castlelike hotel. The hotel looks very much like the Hotel Kaaterskill, which burned in 1920.

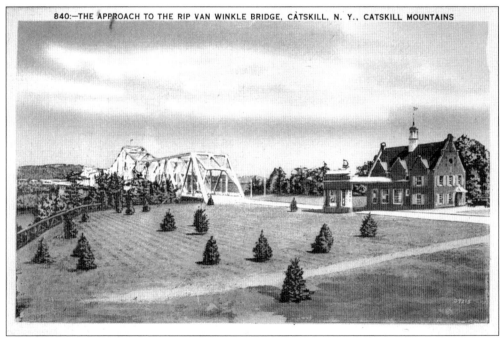

840:—THE APPROACH TO THE RIP VAN WINKLE BRIDGE, CATSKILL, N. Y., CATSKILL MOUNTAINS

A very significant 20th-century monument to Rip Van Winkle's enduring popularity is the naming of the Rip Van Winkle Bridge. Playing on the Dutch heritage of the Central Hudson region, the tollhouse, with its high peaked roof, is modeled after a 17th-century Netherlandish building.

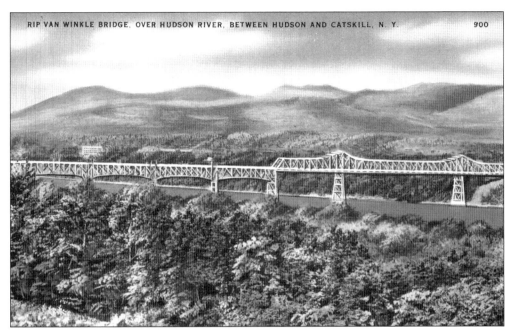

The Rip Van Winkle Bridge connects two historic river towns: Hudson, on the east bank, and Catskill, on the west. The bridge replaced ferry service dating to the 18th century. Opened July 2, 1935, the cantilever bridge cost $2.5 million to build. The bridge is 5,041 feet long, with a main span of 800 feet. Its setting is dramatically beautiful. Artist Frederick Edwin Church's Moorish fantasy house Olana looks down on the bridge from a hilltop outside Hudson. As a steamer crosses under the tall, impressive Rip Van Winkle Bridge, try to imagine that it is the *Washington Irving* (which actually had three smokestacks) or the *Rip Van Winkle.*

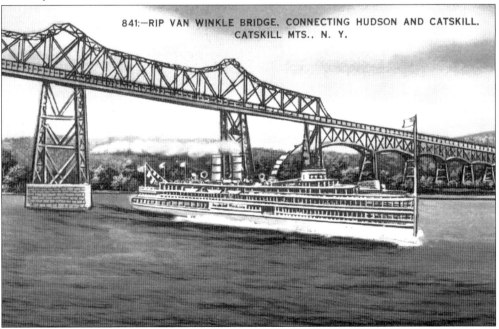

841:—RIP VAN WINKLE BRIDGE, CONNECTING HUDSON AND CATSKILL. CATSKILL MTS., N. Y.

HAVING LOTS OF EXCITEMENT HERE.

Fantastic fish stories and rivers as grand as the Hudson go hand in hand. In 1910, Lance writes, "Hello Bill, This is the way I am fishing" (above). Tall-tale postcards aside, the true stories of the river's bountiful fish are extraordinary in their own right. In April the river was filled with millions upon millions of silverbacks, or shad, that were easily caught in nets or by pole from the shore. More fantastic, however, were the sturgeon that populated the river. Many of these fish were over 20 feet long. They were laughingly called "Albany beef" because of their size and the large steaks you could cut from them. In the Central Hudson region, there are both a Shad Point and a Sturgeon Point.

HERE'S THE FISH I PROMISED YOU.

Five

RESORTS AND THE
CATSKILLS

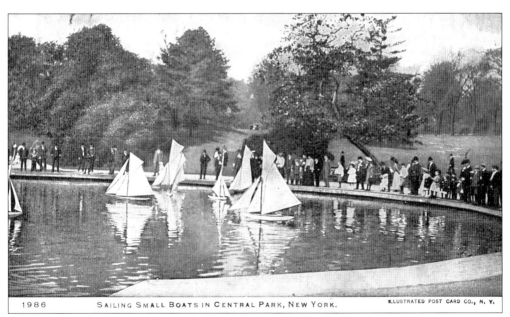

The first popular resorts were landscaped cemeteries and then parks. Parks like New York City's Central Park, designed by Frederick Low Olmstead and Calvert Vaux and dedicated in 1859, gave city dwellers the illusion of being in the country. If you did not have a real sailboat to use on the not-too-distant Hudson, you could sail your miniature, or "pond boat," in the park.

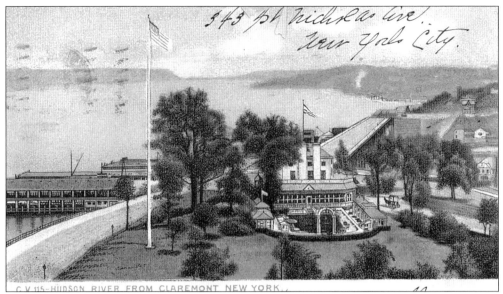

It is hard to imagine upper Manhattan as a summer resort, but then the long narrow island was not completely citified until the early 20th century. The long survival of places such as the Claremont Inn, at Riverside Drive and 123rd Street, is amazing. The obverse of the lower card reads, "The Inn is a historic landmark, overlooking the palisades [sic] and Hudson River – rendezvous of the upper 400. Formerly the residence of Joseph Bonaparte – who later became King of Spain." The Claremont, a former country estate, was in a spectacular location and also had its own pleasure dock on the river. In the *c.* 1907 views, cars and a horse-drawn carriage are drawn up in front of the inn. Gracie Mansion, the official residence of the mayors of New York, is the remnant of a river-view country estate. Another rare survival is the Abigail Adams Smith Museum, built in 1799, which had actually once been a river-view hotel.

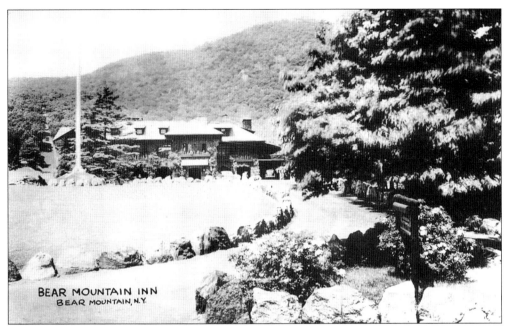

BEAR MOUNTAIN INN
BEAR MOUNTAIN, N.Y.

Bear Mountain State Park is a unit of the Palisades Interstate Park Commission of New York and New Jersey. It was formed, in part, by a gift of 10,000 acres of land by Mary Harriman, whose family maintained a nearby estate named Arden House. Under the leadership of banker George W. Perkins, the park quickly became one of the most popular destinations on the Hudson River. While summer and the Hudson are often synonymous, Bear Mountain Park was to be a year-round operation. The sturdy, native-stone Bear Mountain Inn was opened in 1922, at about the same time that a ski run was constructed. In the winter, the park could be accessed from its own railroad station as well as by road.

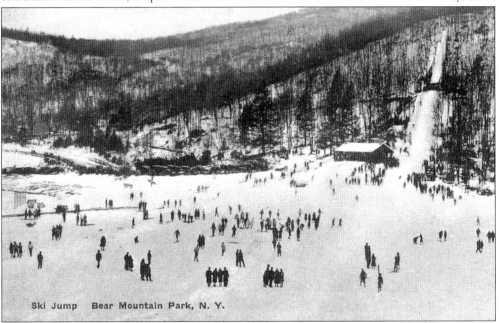

Ski Jump Bear Mountain Park, N. Y.

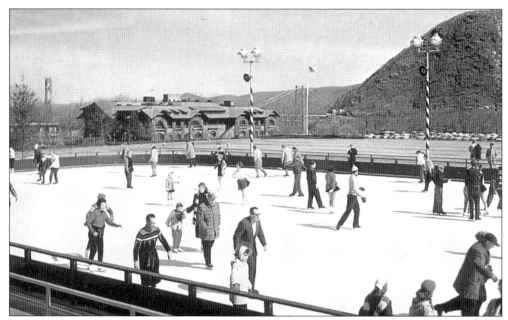

"The spacious out-of-doors artificial ice rink at Bear Mountain is one of the most popular attractions for winter sports enthusiasts. The nearby Bear Mountain Inn is seen in the background," states the legend on the obverse of this postcard. Built after World War II, the rink is a testimony to the park's continued popularity. The Hudson River Day Line, in season, still runs excursion boats to the park's docks.

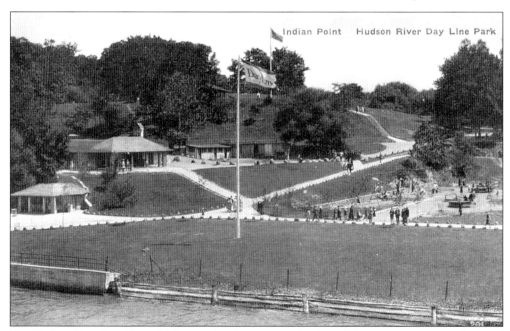

The Hudson River Day Line, which created Indian Point Park, claimed that Native Americans had used the spot as a meeting place. The 320-acre property was developed with facilities for picnicking, swimming, cafeteria eating, and strolling in the woods. There were two piers, and the site even had a vegetable farm to produce food for use on the steamers. Sometimes ships were stored here in the winter. In 1956, the park was sold to Consolidated Edison, which constructed a nuclear power plant on the site.

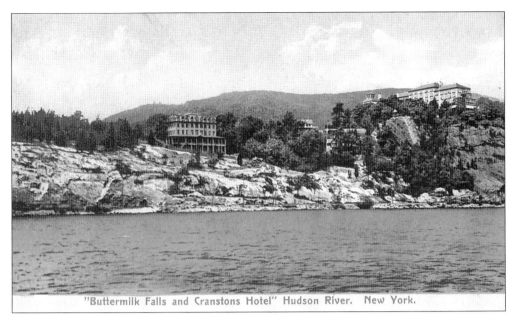

"Buttermilk Falls and Cranstons Hotel" Hudson River. New York.

Hotels started to dot the Hudson's shores beginning in the 1830s. David Parry, whose gristmill was operated by water from Buttermilk Falls, opened one of the first of these. The Buttermilk Falls and Cranstons hotels are successors. Highland Brook cascaded into the Hudson with such force that milk-white foam spread on the water. Dutch navigators called it *Boter Meick Val*. The village of Buttermilk Falls is now called Highland Falls, and it is a service village for West Point. Civil War monuments dot the lowlands in front of the Cravens House, snuggled against the Palisades.

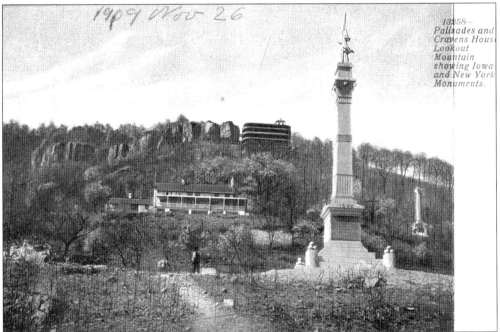

1909 Nov 26

13258 – Palisades and Cravens House Lookout Mountain showing Iowa and New York Monuments.

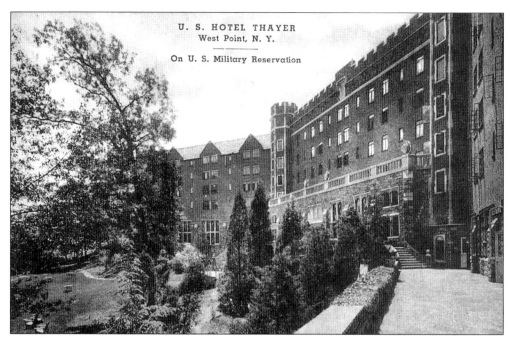

U. S. HOTEL THAYER
West Point, N. Y.

On U. S. Military Reservation

One of the most spectacular hotels along "America's Rhine" is the Hotel Thayer, on the grounds of the United States Military Academy at West Point. Only the hotel recently developed from the castellated estate mansion Carrollcliffe, looming over the Tappan Zee Bridge in Tarrytown, comes close to the Thayer. However, the Thayer, constructed in 1924 and renovated in 1978 and in 2000, is larger and in a class by itself. Named for Sylvanus Thayer, an early commandant, it is a center of the social life of the officers on base and headquarters for visiting families and lovers. The author, a decidedly unmilitary sort, enjoyed being saluted every time he entered the hotel grounds through the gatepost at the foot of the driveway.

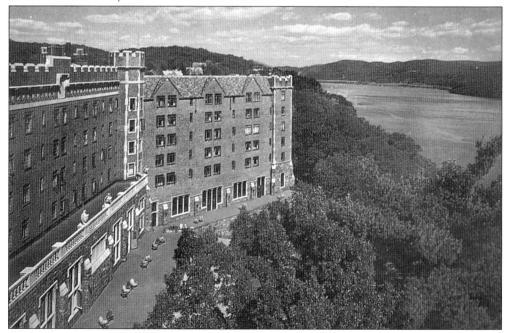

The scenery around here is fine it must be great in the summer. from, Paul.

Vacation spots could also be intimate. The little cabin, perched at waterside near Peekskill, certainly speaks of a no-frills cottage where one could enjoy the scenery and the river for boating and swimming. The Locust Grove Inn, below, is a modest establishment housed in a Dutch Colonial-style bungalow. Located in Rhinebeck, named by Palatinate Germans in the 18th century, the region was a popular summer spot for owners of grand estates as well as for folks of more modest means. Minnie writes in August 1930, "We are spending a vacation here lovely Country. With fine trees."

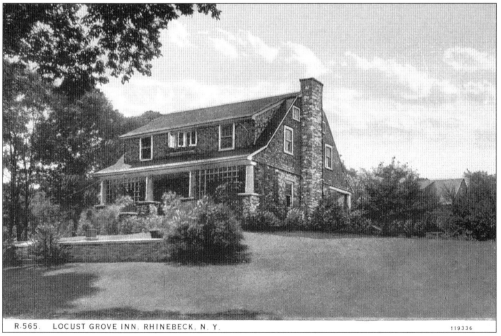

R-565. LOCUST GROVE INN, RHINEBECK, N. Y. 119336

95

The Catskills, on the west side of the Hudson River, became America's first great resort area. The Hudson was the gateway to these wondrous mountains. Early-20th-century travel writer T. Morris Longstreth praised the beauty of the Catskills, but observed, "There is nothing big about the

Catskills . . . They are as comfortable as home." In this 1920s card, all manner of sports are depicted, and Rip Van Winkle's legend is not forgotten.

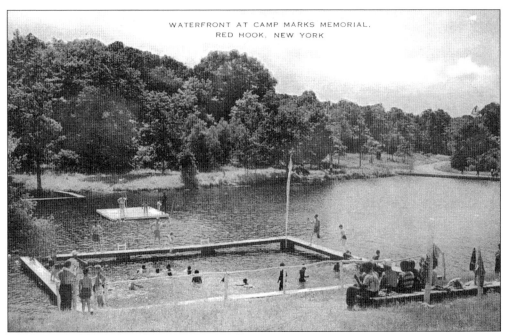

At Red Hook, slightly inland from the Hudson's east bank, was the Marks Memorial Camp, shown in these 1940s cards. Camp Marks was one of six Fresh Air Fund Camps for New York City children, run by the now defunct New York Herald Tribune company, a longtime rival of the New York Times. The Hudson Valley from Peekskill up and the Catskills are dotted with summer camps. Some are charity camps; some belong to Scout councils; others cater to more affluent middle-class children.

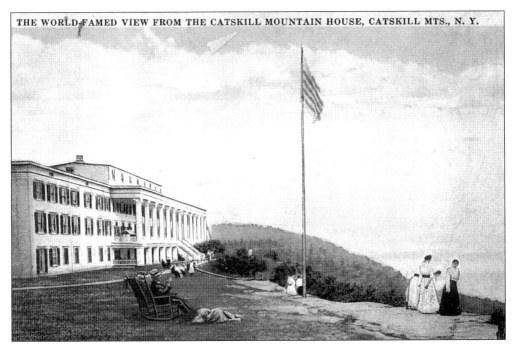

The Catskill Mountain House, begun in the 1820s, was the subject of numerous paintings by Hudson River school artists, including Thomas Cole and Jasper Francis Cropsey (1823–1900). The pioneer, grand, Christian-only hotel in the Catskills remained dominant for 100 years and was the inspiration for scenically-sited hotels across the country. Looking at the view was a favorite pastime at the very expensive Mountain House. The Hudson is 12 miles away. Every guest got up before dawn at least once a season to watch the sensational sunrise over the Hudson. The hotel became a Jewish resort in 1930. Later acquired by New York State, the hotel, visible to river travelers for over a century, was burned to the ground, ironically, by the New York State Conservation Department on January 24, 1962.

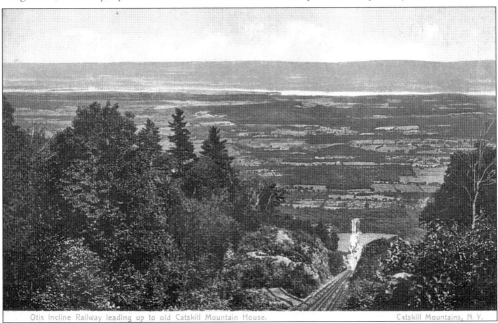

Otis Incline Railway leading up to old Catskill Mountain House. Catskill Mountains, N. Y.

99

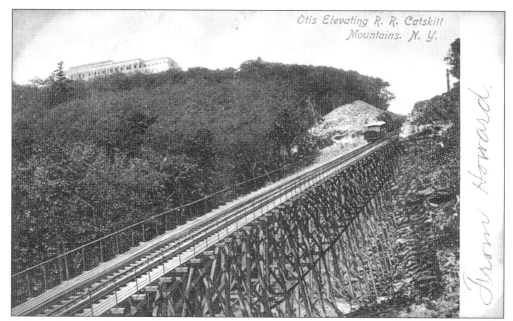

In the early years, the trip to the Catskill Mountain House was long. It involved taking a steamer to Catskill and then a stage to the hotel. That changed in the 1880s, when the Catskill Mountain Railway was constructed, with a stop at the foot of the mountain. In 1892, the Otis Elevated Railroad was built up the mountainside directly to the hotel. Rail travel made it possible for day-trippers to enjoy the fabulous view.

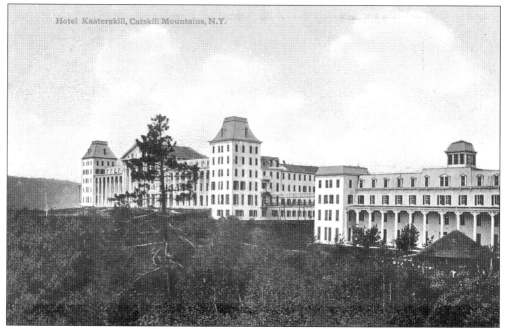

The 1,200-room Hotel Kaaterskill was built to compete with the Catskill Mountain House. The spelling "Kaaterskill" was not old Dutch but rather an adaptation by Mrs. George W. Harding, whose husband constructed the grand hotel in 1881. In September 1924, the hotel burned in a spectacular fire which was seen all the way to Massachusetts.

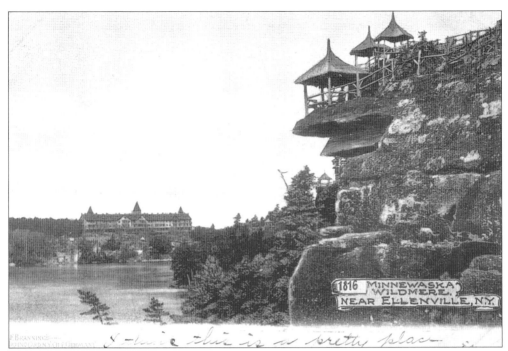

1816 MINNEWASKA WILDMERE, NEAR ELLENVILLE, N.Y.

Twin brothers Albert Keith Smiley and Alfred Houmans Smiley built some of the Hudson Valley's greatest resorts. In 1887, Albert Smiley built the Wildmere Hotel near his earlier hotel, the Lake Minnewaska Mountain House, in the midst of a 9,000-acre tract he owned. Both Wildmere and the Cliff House, as the Lake Minnewaska Mountain House was renamed in 1887, burned. After much bitter squabbling, New York State acquired this peerless site for a state park in the late 1980s. Alfred Smiley's Mountain House, at nearby Lake Mohonk, was built in 1879 and was enlarged at various times, lastly when the dining room was extended in 1910. Still owned and meticulously maintained by the Smiley family, this national historical landmark retains all of its vintage charm and is the last of the great Victorian Hudson Valley hotels in existence.

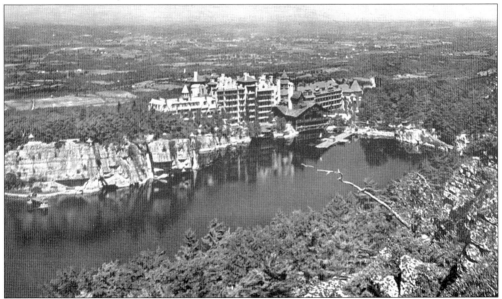

101

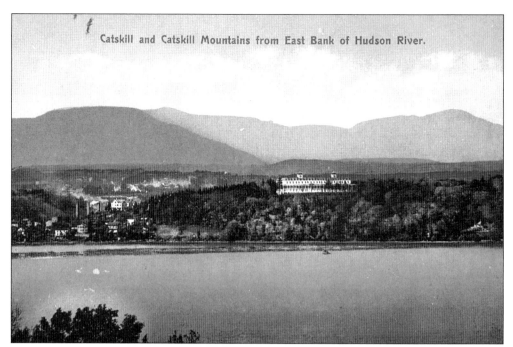

Catskill and Catskill Mountains from East Bank of Hudson River.

Hotels, Catskills, and the Hudson River are a continuum with changing components. In *A Catskill Boyhood: My Life Along the Hudson: 1908–1921*, Philip H. DuBois, a descendant of a Huguenot family who settled in the valley in the 17th century, writes about the hotels near his family home and the spectacular fire one suffered. The scene of Catskill and the mountains beyond dates from *c.* 1910. The lower card shows the 1950s pool of the Peekskill Motor Lodge, overlooking the Hudson. The automobile has clearly changed the region's dynamics. The Peekskill Motor Lodge offers "54 luxuriously appointed units with TV, telephone, wall-to-wall carpeting, ceramic tiled bath and show[er] combinations. Set in beautiful and historic Hudson Valley. Corner Routes 6-202-35 and 9."

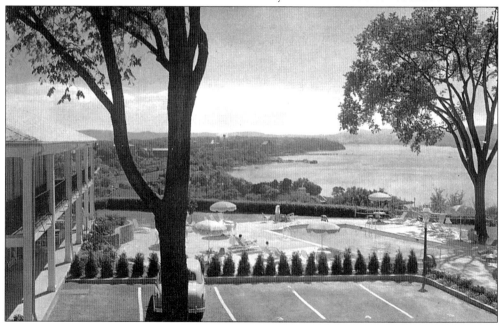

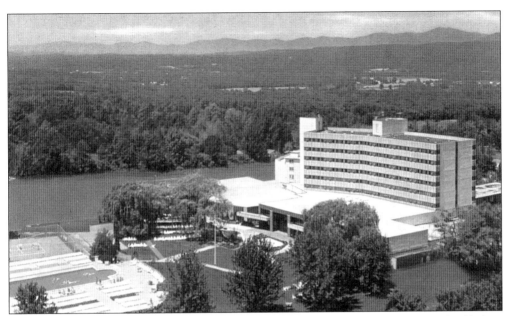

The Granit Hotel, in Kerhonkson, was a Borscht Belt hotel that wanted to emulate the fabulous Concord at Kiamesha Lake. Located in a beautiful setting, the Granit is visible from the Lake Mohonk Mountain House, above, on one of the distant mountains. After going into bankruptcy in 1997, the Granit emerged fresh from a $25 million renovation as the Hudson Valley Resort Spa and was called the "jewel of the Catskills." Hyperbole lives on.

Helping to keep the resort life healthy in the Hudson Valley is the region's own CIA—the Culinary Institute of America. "Located on a beautiful 75 acre campus on the Hudson River [it] is the largest vocational college in the United States devoting its curriculum exclusively to professional food service." Housed in a former monastery, it is awesome at class break to see hundreds of white-clad chefs-in-training milling around, in a different uniform, of course, but similar in feeling to the monks' habits of their predecessors.

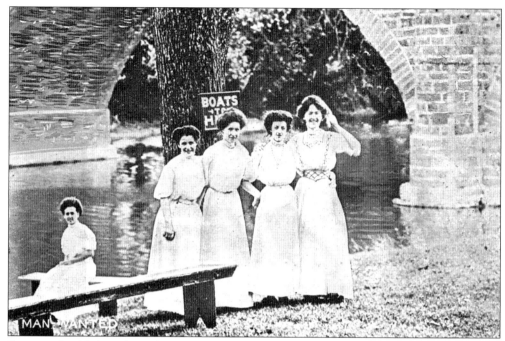

Romance should always be in the air at resorts. These early-20th-century postcards explore the issues. In the 1910 card above, the legend says "MAN WANTED." On the 1907 card below, man and woman have met each other, but "progress," in the form of railroad surveyors, is getting in the way of romance. In the Hudson Valley today, there are still great pressures on the natural beauty. It is no longer an issue of railroads, but of power plants and transmission lines. An unsigned message on the back asks, "Do you think it's likely to be as interesting as this, they should have brought their meals along, don't you think?"

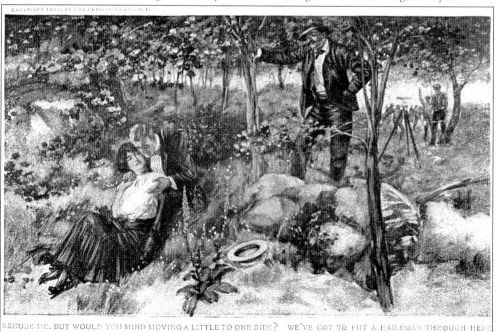

EXCUSE ME, BUT WOULD YOU MIND MOVING A LITTLE TO ONE SIDE? WE'VE GOT TO PUT A RAILROAD THROUGH HERE

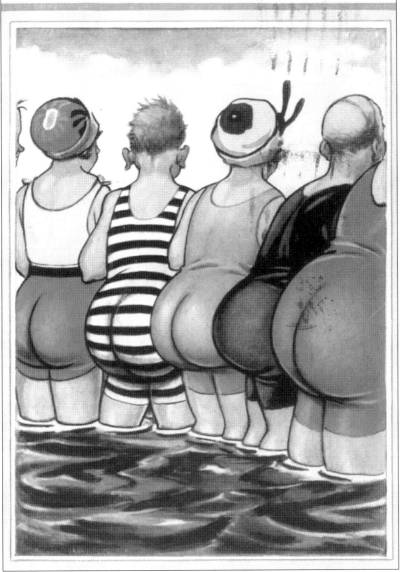

Swimming in the Hudson has a long history. The Native Americans swam in the water, as did generations of European Americans. By the middle of the 20th century, many parts of the river were so polluted that swimming was hazardous. In the last three decades, a great deal of progress has been made in cleaning up the river, and swimming is possible in many places. What swimmers look like is another issue. The view of many suit-clad swimmers is often inferior to the vistas of the Hudson. This postcard was mailed in 1929.

Who vacations and why? This has been explored by scholars and in the racks of comic cards sold in resort areas everywhere. The rise in the popularity of vacations mirrors the rise of the democratic instinct that sees the vacation as a new entitlement, but one with which people are still uncomfortable. The image is that once a marriage is consummated and all of those young women of two pages ago have found their "MAN WANTED," everyone does not always live happily ever after—even on vacation.

Six

THE CAPITAL REGION

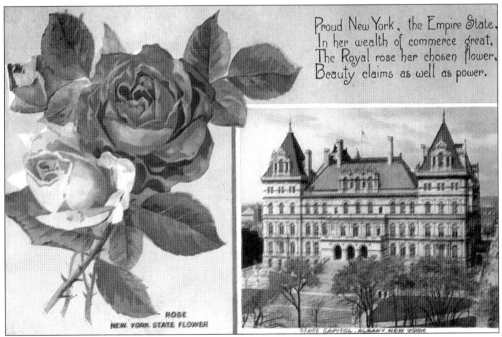

Proud New York, the Empire State,
In her wealth of commerce great,
The Royal rose her chosen flower,
Beauty claims as well as power.

ROSE
NEW YORK STATE FLOWER

STATE CAPITOL, ALBANY, NEW YORK

How very appropriate that the rose would be chosen as the official state flower and shown on this *c.* 1905 postcard along with a vignette of the state capitol. New York's two governors who went on to become presidents were both named Roosevelt, which roughly translates as "rose field." Theodore Roosevelt was the 26th president; Franklin Delano Roosevelt was the 32nd. They were distant cousins, even before Franklin married Eleanor Roosevelt, Theodore's niece.

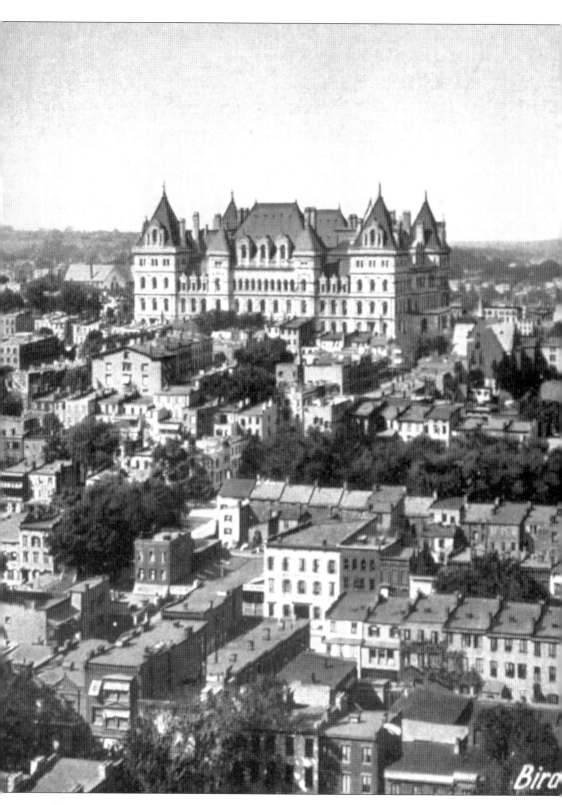

Bird

ew of the Capitol and Albany, N.Y.

The site of Albany was visited by Henry Hudson on September 19, 1609. In 1623, the Dutch West India Company sent 30 Walloon (Belgian) families to settle in the area. They built a fort they named Fort Aurania after the Dutch royal family. Aurania translates into "orange" in English. After the English conquered the New Netherlands in 1664, Fort Orange's name was changed to reflect the new political establishment. New Amsterdam and the New Netherlands were renamed New York in honor of their captor, James Stuart, Duke of York, who also held a Scottish title, the Duke of Albany. During the French and Indian War, a congress was held in Albany, attended by many important figures, including Benjamin Franklin. The Albany Plan of Union they adopted became, in part, the blueprint for our post-Revolutionary government. Albany became the capital of New York in 1797. In this *c.* 1905 postcard, the Hudson is out of view, obscured by buildings, but it runs in front of the mountains.

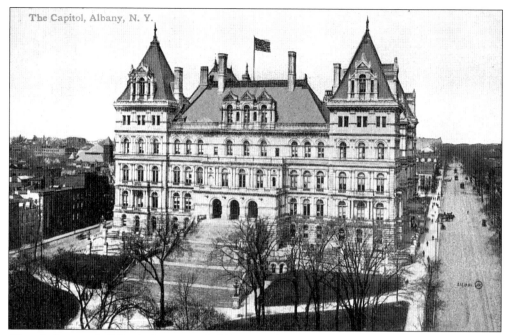

The Capitol, Albany, N. Y.

Albany's signature building is the state capitol. Because of partisan and aesthetic squabbling, the building, which combines elements of the French Chateauxesque and Romanesque Revival styles, took 32 years to build—from 1867 to 1899. Two of the most important American architects of the 19th century worked on it: Henry Hobson Richardson, who introduced the Romanesque Revival style, and Richard Morris Hunt, who designed the base for the Statue of Liberty. Both architects had been trained in France. The building's interior is richly decorated, most notably by murals done by William Morris Hunt, the architect's brother.

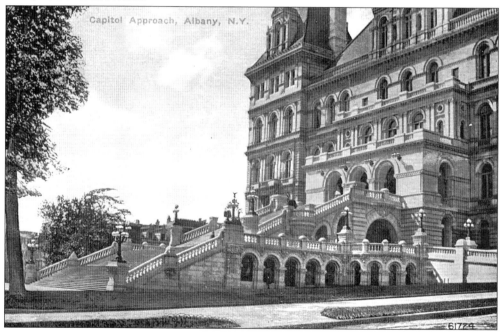

Capitol Approach, Albany, N. Y.

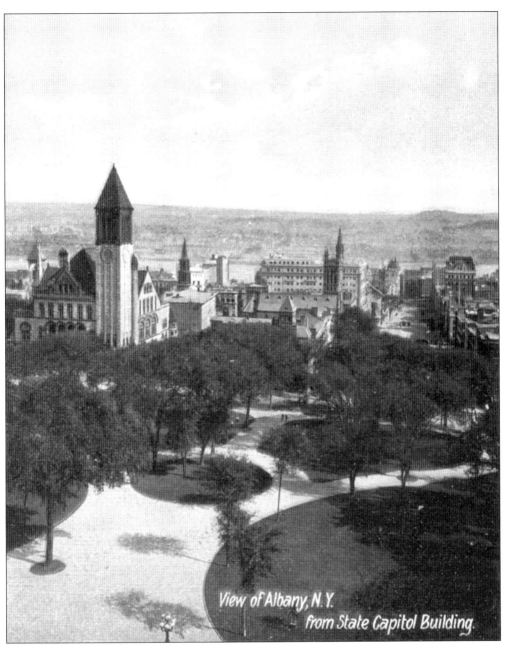

View of Albany, N.Y. from State Capitol Building.

The steamboat, a canal system, and railroads, along with the state government, made Albany into a vital city of modest size. As a metropolitan area, it had long been overshadowed by Buffalo to the west and New York City 150 miles to the south. In this *c.* 1905 view, the Hudson is clearly seen in the distance. The near tower is city hall. The tower in the right distance is the Delaware and Hudson Railroad headquarters.

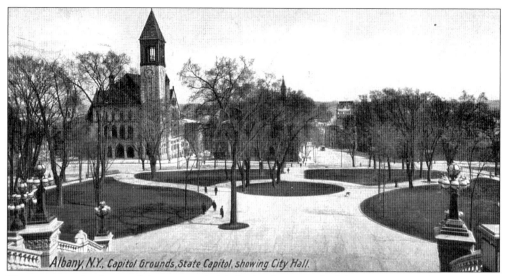

The ornamental stairway of the state capitol is in the foreground of this 1906 postcard, sent to Anna Hiscock in Kingston. The view shows a leafy park, across which stands Albany's city hall.

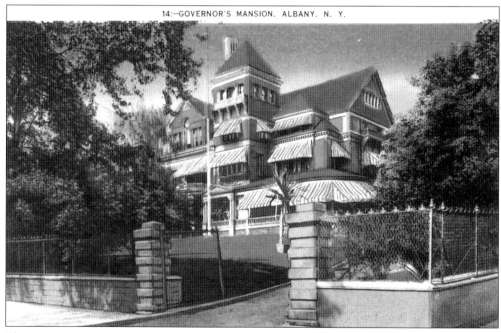

The governor's mansion in Albany was the home of one of the city's elite before being purchased by New York State. In subsequent years, many governors have complained about it. It was extensively renovated after a fire during the administration of Gov. Nelson A. Rockefeller in the 1960s. Modern transportation has made it possible for most recent governors, who have all been from New York City or the Hudson Valley, to sleep in their own homes many nights of the week.

112

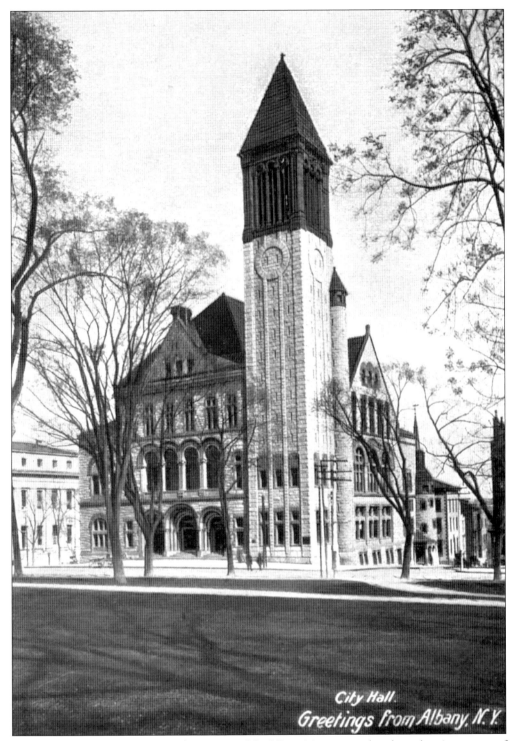

City Hall

Greetings from Albany, N.Y.

Very conscious of the monumental state capitol building rising across the plaza, the city powers of Albany constructed a very impressive city hall, done in the fashionable Richardson Romanesque, or Romanesque Revival, style, characterized by the square tower and broad arches.

113

The Delaware and Hudson and Journal Building, in the author's opinion, was the most impressive building constructed in Albany until Gov. Nelson Rockefeller initiated the construction of the monumental Empire State Plaza. The huge building in sight of the capitol housed the powerful Delaware and Hudson Corporation, with its vast empire of canal, railroad, barges, terminals, warehouses, coal lands, and the Albany *Journal*, one of the capital city's most important newspapers. The

structure, in Flemish Gothic style, was inspired by the Clothe Hall in Ypes, Belgium. It is topped by a nine-foot model of Henry Hudson's ship *Half Moon*. The building is now state owned and houses the administrative offices of the State University of New York (SUNY). In front of the enormous edifice are trolley cars. The Hudson River is beyond the building, enhanced with a newly completed bridge and a steamer.

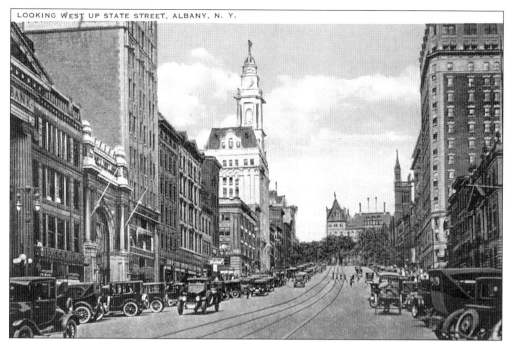

State Street, crowned by the state capitol, was the commercial heart of Albany. On this early-20th-century postcard, above, "The picture shows the remarkable change in the appearance of this street since the new City Savings Bank has been completed. In fact, this picture shows the larger part of our city's banking institutions. On the left in the foreground you see Albany's largest banking institution, the National Commercial Bank and Trust Company . . . The Ten Eyck Hotel and St. Peter's Church dominate the picture on the right." The card below, a little later in time, advertises the Hotel Wellington of 136 State Street, "ALBANY'S LARGEST AND ONLY 'GARAGE-IN' HOTEL," which is "Convenient to transportation lines, shopping district and State Office Buildings."

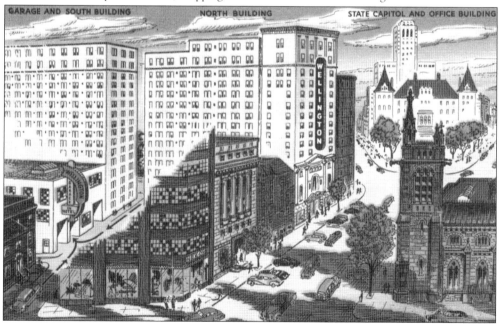

116

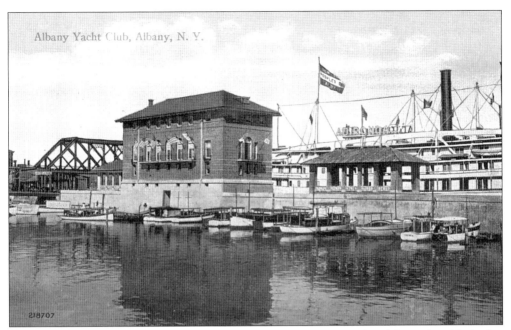

Albany Yacht Club, Albany, N. Y.

Like many river towns, Albany had its yacht club. The Albany Yacht Club shared the Hudson Navigation Dock (illustrated on page 120). The steamer named *Adirondack* is moored in the background. Like most river yacht clubs, the Albany hosted few yachts. Sailboats and small cabin cruisers were more common. At Electric Park, in nearby Kinderhook, you could rent a rowboat for water excursion. Note the roller coaster to the left.

Electric Park, Kinderhook, near Albany, N. Y.

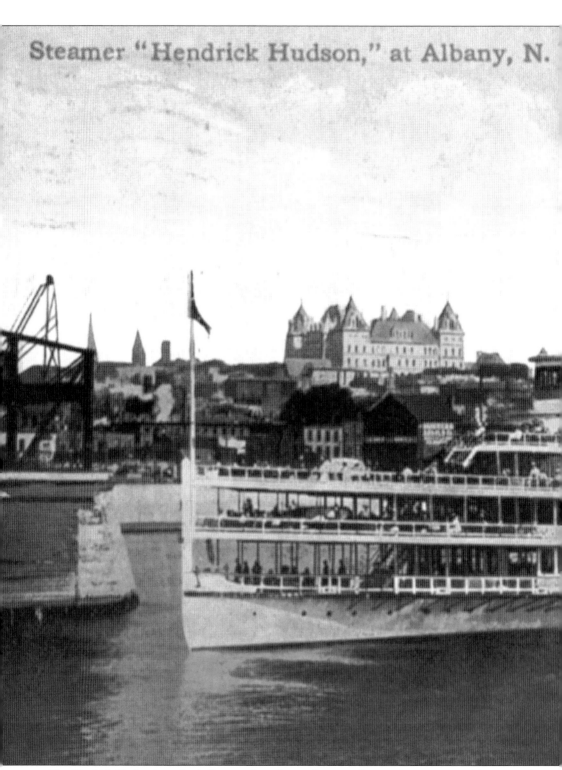

The *Hendrick Hudson* is majestically poised in the Hudson at Albany. The state capitol looms in the distance. Sallie mailed the card in September 1910 to "Mr. Saul Winkelman, St. Ignace, Mich." The card

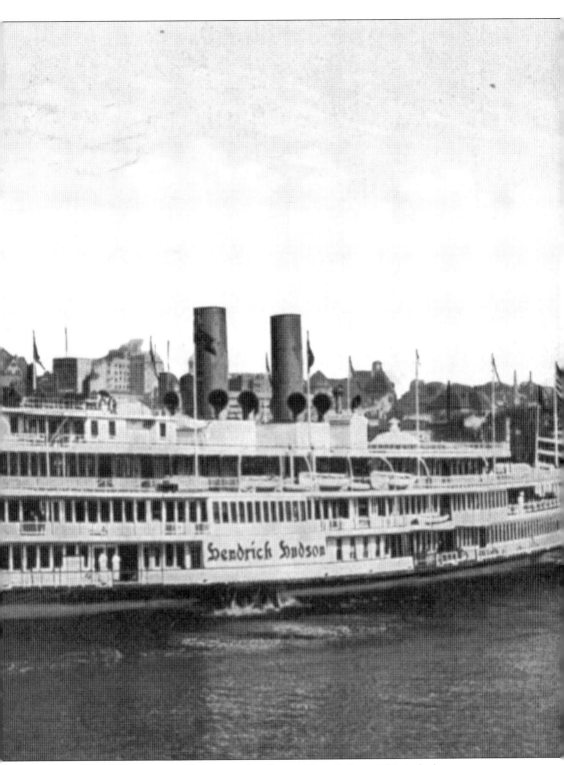

reads, "Dear Cousin Saul – We are having one fine time visiting all places. This is the boat we came up on and we are going back on the same boat, we have been away 10 days. Love from myself & hubby."

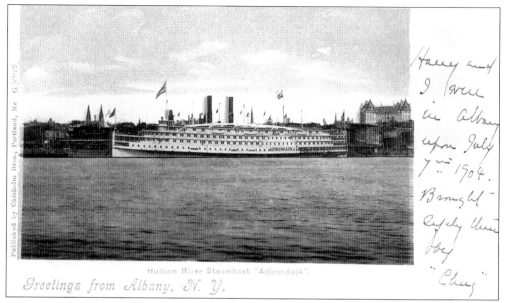

Hudson River Steamboat "Adirondack".

Greetings from Albany, N. Y.

Never mailed, this 1904 card was no doubt used as a photographic souvenir of a stop that was part of a larger trip. The card shows the steamer *Adirondack*, a vessel that traveled up to Lake Champlain, on the Hudson at Albany.

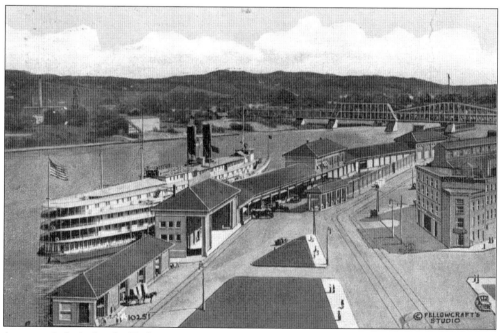

A steamer is docked at the Hudson Navigation Dock at Albany. Many trips to Albany were nighttime or sleeper trips, taken more for pleasure than mere transportation. Writing to her parents in Buffalo in 1927, Wilma reports, "Arrived here at Albany O.K. Slept occasionally thru the night. Not bad for my first experience in a sleeper."

120

Port of Albany, Largest Grain Elevator in the World, Albany, N. Y. 183

New: Helping Albany to be prosperous in the pre-World War II years were a series of public works. In 1918, great improvements were made to the New York State Barge Canal. Fourteen years later, in 1932, the new $13 million port of Albany development was opened. Its facilities, including the grain elevator seen above, covered 217 acres. The river, after dredging, could now accommodate oceangoing ships with a 27-foot draft.

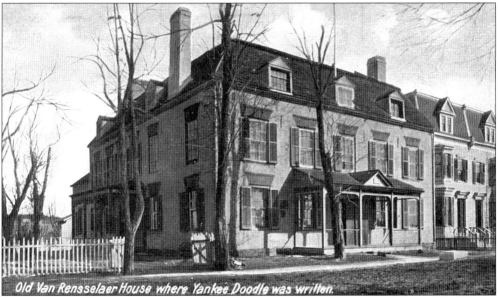

Old Van Rensselaer House where Yankee Doodle was written.

Old: For many years the Van Rensselaer family was the major political and economic force in the Capital Region. Their 24- by 48-mile tract of land centered on Fort Orange. Across the Hudson, the Van Rensselaers built a house called Fort Crailo in 1704, at what was known as Greenbush, now part of the city of Rensselear. The home was expanded and remodeled over the years. During the French and Indian War, it is alleged that Dr. Richard Shuckburgh wrote "Yankee Doodle" in the house. This is a 1908 view. In the 1930s, Fort Crailo was restored to its 1704 appearance. Today it is a museum.

121

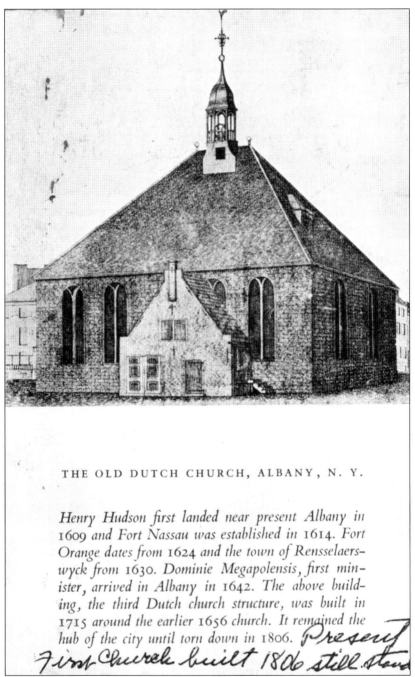

THE OLD DUTCH CHURCH, ALBANY, N. Y.

Henry Hudson first landed near present Albany in 1609 and Fort Nassau was established in 1614. Fort Orange dates from 1624 and the town of Rensselaerswyck from 1630. Dominie Megapolensis, first minister, arrived in Albany in 1642. The above building, the third Dutch church structure, was built in 1715 around the earlier 1656 church. It remained the hub of the city until torn down in 1806. Present

First Church built 1806 still stand

In 1806, members of Albany's Dutch Reformed congregation tore down the most important Dutch Colonial building in their city. The interior of the 1735 church followed the basic floor plan of the 1656 church which, in part, served as a vestibule for the newer structure. The handsome church that replaced this now lost structure is designed in the Anglo-American church tradition. We owe a great deal of our knowledge of no-longer-standing Dutch buildings in Albany to James Eights (1798–1882), a scientific draftsman by trade, who did a series of views of Albany as it was in 1805. The views were first published from *c.* 1847 to *c.* 1854.

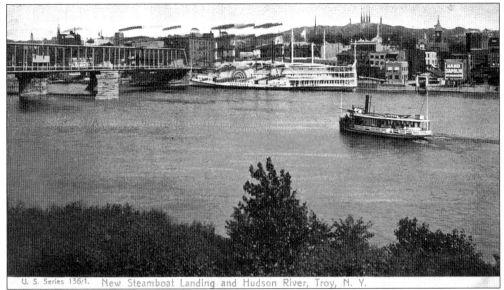

U. S. Series 136/1. New Steamboat Landing and Hudson River, Troy, N. Y.

Troy, at the head of tidewater navigation of the Hudson, was part of the Rensselaer holdings which indelibly influenced the whole Capital Region. The 19th century was the golden age for Troy. The first bridge to cross the Hudson was built here in 1835 by the Rensselaer and Saratoga Railroad. Constructed of wood, it burned in 1862. The city is home of Rensselaer Polytechnic Institute, an engineering school founded by Stephen Van Rensselaer in 1824. River steamers were important to Troy, which had regular connections with Albany. The view of the new steamboat landing was mailed in 1906. Many disembarking passengers quite fittingly stopped at the Hotel Rensselaer which, staying within a Dutch motif, called its dining room the Rip Van Winkle Room. The furnishings, in the early 20th century, would have been called "Dutch."

RIP VAN WINKLE

ROOM

Hotel Rensselaer

TROY, N. Y.

J. McGlynn
H. A. McGrane

Albany, Rensselaer, Troy, and the whole Capital Region owed a great deal of its importance and prosperity to the many canals that linked the Hudson to other bodies of water, opening them to steamboat and, especially, barge traffic. The first major canal opened was the Hudson River and Champlain Canal in 1822, which made modern navigation between river and lake possible. The canal is

seen in the front with a view of Wiburs Basin to the rear. The basin stored water used to maintain the canal at navigable levels. The basin is near where the Battle of Saratoga was fought, during the Revolution. The Erie Canal, opened in 1825, and the Delaware Canal, opened in 1828, were of even greater import and made the Capital Region one of America's leading trade and transportation centers.

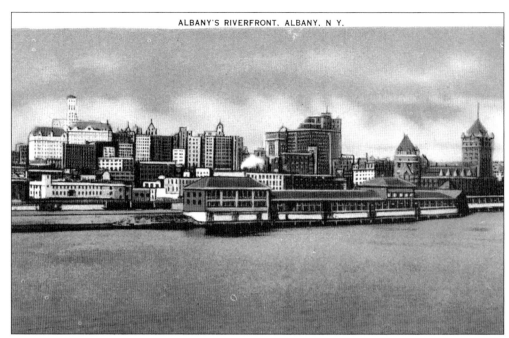

By the 1950s, the bloom was off the Capital Region's transportation rose. River traffic and railroads had become much less significant as the automobile-and-truck era evolved. Albany was no longer a destination, except for lawmakers, but, more commonly, a stopover. Gussie and Bill, writing on the night scene card in 1950, "Spending a day in Albany on our way home from Vermont. Had a wonderful time." The legend on the back of the card boasts of Albany's colonial past and ends that "It has always been an important transportation center." But the river is empty and the old Hudson Navigation Docks, in the foreground, are largely unused. Today, Albany actively promotes itself as a tourist destination, boasting of its museums and its cultural opportunities.

Albany Skyline, at Night, Albany, N. Y. 27

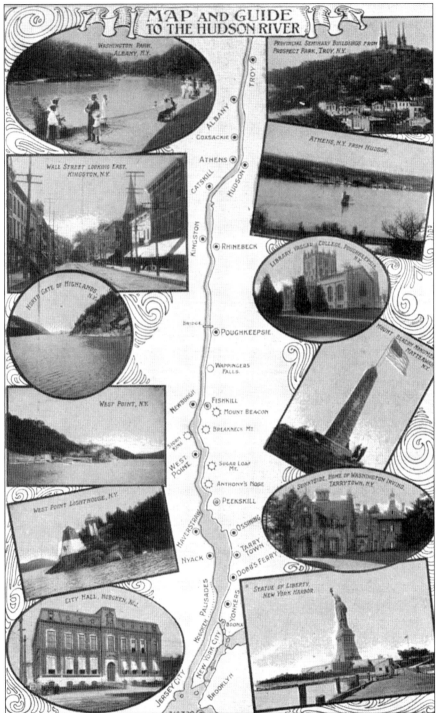

At the end of our journey is a map of where we have traveled. This *c.* 1905 card, published by Valentine and Sons of New York and Boston, is embellished with vignettes from the Statue of Liberty, in New York Harbor, to Washington Park, in Albany, and Prospect Park, in Troy. We hope you enjoyed the trip. Visit again.

127

Bibliography

Adams, Arthur G. *The Hudson: A Guidebook to the River*. Albany, New York: State University of New York Press, 1981.

Adams, Arthur G. *Hudson River Through the Years*. New York: Fordham University Press, 1996.

Boyle, Robert H. *Hudson River: A Natural and Unnatural History*. New York: Norton, 1979.

Carmer, Carl. *The Hudson*, revised. New York: Grosset and Dunlap, 1967.

Cooper, James Fenimore. *The Spy: A Tale of Neutral Ground*. Reprint. New York: Viking Penguin, 1997.

Driscoll, John. *All That is Glorious About Us: Paintings from the Hudson River School*. Ithaca, New York and London: Cornell University Press, 1997.

DuBois, Philip H. *A Catskill Boyhood: My Life Along the Hudson, 1908–1921*. Hensonville, New York: Black Dome Press Corporation, 1992.

Evers, Alf. *The Catskills From Wilderness to Woodstock*. Garden City, New York: Doubleday and Company, Incorporated, 1972.

Gannon, Peter Steven, ed. *Huguenot Refugees in the Settling of Colonial America*. New York: The Huguenot Society of America, 1985.

Irving, Washington. *Diedrich Knickerbocker's History of New York*. Reprint. New York: The Heritage Press, 1940.

Irving, Washington. *The Legend of Sleepy Hollow*. Reprint. New York: New American Library, 1997.

Irving, Washington. *Rip Van Winkle*. Reprint. New York: Little, 1991.

Jackson, Kenneth T., ed. *The Encyclopedia of New York City*. New Haven, Connecticut and London: Yale University Press, 1995.

Jameson, J. Franklin. *Narratives of New Netherlands, 1609–1664*. New York: Barnes & Noble Inc., 1909.

Lossing, Benson J. *The Hudson River From the Wilderness to the Sea*. Troy, New York: Nims and Company, 1866.

O'Neil, John P., ed. *American Paradise: The World of the Hudson River School*. New York: The Metropolitan Museum of Art, 1988.

Richman, Irwin. *The Catskills in Vintage Postcards*. Charleston, South Carolina: Arcadia Publishing, 1999.

Rubin, Cynthia Elyce, and Morgan Williams. *Larger Than Life: The American Tall Tale Postcard, 1905–1915*. New York: Abbeville Press, 1990.

Ryan, Dorothy B. *Picture Postcards in the United States, 1893–1918*, updated edition. New York: Clarkson N. Potter, 1982.

Simpson, Jeffrey. *Hudson River: 1850-1918: A Photographic History*. Tarrytown, New York: Sleepy Hollow Restorations, 1981.

Stanne, Stephen P. *An Illustrated Guide to a Living River*. New Brunswick, New Jersey: Rutgers University Press, 1996.

Wharton, Edith. *The Age of Innocence*. Reprint. New York: Modern Library, 1999.

Wharton, Edith. *The House of Mirth*. Reprint. New York: Norton, 1999.

Wharton, Edith. *Hudson River Bracketed*. Reprint. New York: Scribners Ref., 1985.

Zukowsky, John, and Robbe Pierce Stimpson. *Hudson River Villas*. New York: Rizzoli, 1985:7.